# THE SUBSTANCE *of* THINGS SEEN

The CALVIN INSTITUTE OF CHRISTIAN WORSHIP LITURGICAL STUDIES Series, edited by John D. Witvliet, is designed to promote reflection on the history, theology, and practice of Christian worship and to stimulate worship renewal in Christian congregations. Contributions include writings by pastoral worship leaders from a wide range of communities and scholars from a wide range of disciplines. The ultimate goal of these contributions is to nurture worship practices that are spiritually vital and theologically rooted.

## Available

*Gather into One: Praying and Singing Globally*
C. Michael Hawn

*The Substance of Things Seen: Art, Faith, and the Christian Community*
Robin M. Jensen

*Discerning the Spirits:*
*A Guide to Thinking about Christian Worship Today*
Cornelius Plantinga Jr. and Sue A. Rozeboom

*My Only Comfort: Death, Deliverance, and Discipleship*
*in the Music of Bach*
Calvin R. Stapert

*Christian Worship in Reformed Churches Past and Present*
Lukas Vischer, Editor

# THE SUBSTANCE *of* THINGS SEEN

## Art, Faith, and the Christian Community

Robin M. Jensen

WILLIAM B. EERDMANS PUBLISHING COMPANY

GRAND RAPIDS, MICHIGAN / CAMBRIDGE, U.K.

Wm. B. Eerdmans Publishing Co.
255 Jefferson Ave. S.E., Grand Rapids, Michigan 49503 /
P.O. Box 163, Cambridge CB3 9PU U.K.
www.eerdmans.com

Printed in the United States of America

09  08  07  06  05  04      7  6  5  4  3  2  1

**Library of Congress Cataloging-in-Publication Data**

Jensen, Robin Margaret, 1952-
    The substance of things seen: art, faith, and the Christian community /
    Robin M. Jensen.
        p.      cm. — (The Calvin Institute of Christian Worship liturgical studies series)
    Includes bibliographical references.
    ISBN 0-8028-2796-9 (pbk.: alk. paper)
    1. Aesthetics — Religious aspects — Christianity.  2. Christianity and art.
    I. Title.  II. Series.

  BR115.A8J46    2004
  246 — dc22

                                        2004042361

Unless otherwise noted, the Scripture quotations in this publication are from the New Revised Standard Version of the Bible, copyright © 1989 by the Division of Christian Education of the National Council of Churches of Christ in the U.S.A., and used by permission.

# Contents

# Series Preface

Christian worship is aided immeasurably by our sense of sight. In worship, we see each other and gain a glimpse of what it means to be the body of Christ. In worship, we are privileged to see beautiful and thought-provoking — or at least well-intentioned — expressions in fabric, wood, stone, and light. And what we see is shaped by the architectural contours of our worship space. For better or worse, our buildings invariably unveil implicit assumptions about God and the church, and attitudes toward culture and the nature of worship. Even iconoclastic Puritan traditions practiced worship that was sight-full, constructing buildings for worship that spoke an eloquent visual language of luminous simplicity.

Worship also aims at seeing on a deeper level. The entrance to the Calvin College Chapel announces the conviction of the Psalmist: "In your light we see light" (Ps. 36:9). In worship, we gain a perspective from which to see the world and its true needs most clearly.

But for all the importance of the visual, both literally and metaphorically, most of us average churchgoers have little access to some of the church's best wisdom about either kind of seeing. Most of us worship in communities that either fear or celebrate visual communication, but rarely question or probe it.

In this world, Robin Jensen's balanced voice is most welcome. In the last sentence of her earlier book, *Understanding Early Christian Art*, Jensen concludes, "Both verbal and visual eventually come down to the same thing and reinforce one another." That is a rare kind of sentence in a book about the relationship of verbal and visual communication in Christian practice. For several centuries, many reflections on the topic have dispar-

aged visual communication, either implicitly or explicitly. And the inevitable tendency of students and practitioners of art and architecture has often been to respond with enthusiastic if overstated counterarguments.

This is true not only in academic but also in pastoral discussions. It is often said nowadays that we have re-entered a visual age in which verbal, discursive communication has been overtaken by television and the Internet. Just as the printing press transformed culture from a visual culture to an oral culture, the argument goes, so TV and the Internet are doing the reverse. With a single (suspect) historical argument, a lot of traditional verbal communication is dismissed as quaint.

There is much to be said for the underlying point that visual communication is important in contemporary culture, right alongside of verbal communication. But the historical argument is pretty flimsy. Historians tell us that among the most popular books first printed by the printing press were books of woodcuts — artworks! The printing press did expand literacy, to be sure. But it would be more accurate to say that it helped to create a better balance and integration of visual and verbal communication.

Visual and written or verbal communication have always existed side by side. At their best, they inform and deepen each other. Thanks to Robin Jenson for writing in a way that helps us see how this is so.

This book also comes at a propitious time. The last decade has witnessed a remarkable outpouring of artistic creativity in congregations, as explained, for example, in Robert Wuthnow's *All in Sync: How Music and Art Are Revitalizing American Religion* (University of California Press, 2003). Happily, artists, once routinely ignored, are now more frequently engaged by worshiping communities. The problem is that the underlying vision for the function of the arts in worship is often quite vague. So we have a lot of enthusiasm for new multimedia works, new banners, new sculptures, and renovated buildings, but very little direction about what makes these contributions fitting for Christian worship. The result can be a lot of misspent energy on art forms that demand significant attention but may detract from rather than enhance liturgical participation and community life.

In contrast, here is a book that helps us imagine how seeing more deeply will help us proclaim the gospel more faithfully and pray together more honestly. While the book's scope is certainly wider than what hap-

pens in public worship events, may one of its effects be to refocus the seeing that both shapes and issues from our worship.

JOHN D. WITVLIET
*Calvin Institute of Christian Worship*
*Calvin College and Calvin Theological Seminary*
*Grand Rapids, Michigan*

## Author's Preface

Where would the church be without art? How could faith be expressed without song, poetry, or image? Christianity's central message comes through a story, and within that story are more stories. God didn't drop a bare instruction book out of the heavens but came as a breathing, emotional, and sensate human being. Worship is unimaginable without art, even if it's no more than a silent prayer or even a sigh. Theologians use their imagination and the art of language. But even though the Christian community needs artists, the two worlds of church and art find themselves mutually wary, sometimes even hostile, often with little understanding or appreciation of one another. The church worries that art will go "too far" and draw attention to itself rather than lead the faithful to God. The artists fear that the church will direct or limit their imagination and judge, censor, or abuse their creativity. In this situation, both sides forget that creation is essentially a divine action, and that life itself began with art.

In 1991 I began teaching church history in a theological school that had a reputation for taking the intersection of theology and art seriously. The institution encouraged me to incorporate visual images into my teaching of history, but soon, in addition to showing students how the arts were important to the tradition, I came to understand that those future church leaders and theologians needed to learn about the arts as a way of expressing, exploring, forming, and challenging faith as well as a medium of divine self-revelation. Of course art belongs to the secular as well as the sacred world, and in both realms is powerful as well as dangerous, beneficial as well as detrimental — to society as much as an individual soul. Unless the church engages the arts both critically and appreciatively, its message will

become monotone and irrelevant in a culture saturated with images, music, and drama ranging from the banal to the sublime.

In those first years of teaching, I had the benefit of colleagues and students who were musicians, poets, visual artists, and theatre directors who understood this better than I did. With the encouragement of the institution's administration, we soon formed a program that included courses and workshops, gallery exhibitions, and drama. Along the way, I decided to try to write an accessible introduction to this topic, not only for church groups and seminarians but also for artists who see their work as deeply and powerfully religious.

The six essays that make up the chapters of this book were originally delivered as a series of public lectures in the fall of 2000 at John Carroll University in Cleveland, Ohio. I was invited to John Carroll for that semester as the Walter and Mary Tuohy Chair of Interreligious Studies. In the lectures I hoped to address the ways that the arts — especially the visual arts — can inform the life of faith and nourish the creative life of the church. I also wanted to discuss the many problems that the mutual engagement of the church and the arts has encountered over the centuries and to suggest some ways that lay persons as well as theologians might overcome that difficult legacy. I intended to be critical as well as constructive, realistic as well as hopeful, and as pragmatic as possible. Rather than providing more abstract or theoretical analysis of the relationship of art and Christian faith, I wanted to offer some practical suggestions, ideas, and possible answers to everyday issues and contemporary controversies.

At the same time, I was very conscious, while giving these lectures, that I was speaking as an academic to a public audience, and so wanted to offer some insights that were also broad and general rather than focused and scholarly. I deliberately chose a diverse range of topics rather than a narrow field in order to give as big a picture as possible in a short time. Aware that I was speaking as a Protestant woman within a Catholic university, I assumed that some audience members would have very different experiences of the subjects I was discussing. For this reason I decided to describe some of my own experiences, and used examples and anecdotes both to give some context and concreteness to my ideas in personal encounters as well as to illustrate my arguments. My intention was not to make a final judgment about most of these matters but merely to open the conversation. I also welcomed the opportunity to make a small contribution to the newly

ignited interest in the arts and the creative imagination within religious communities in an ecumenical setting.

I have many people to thank for their hospitality, help, and friendly support during my semester at John Carroll and my subsequent time spent transforming the lectures into written essays. I especially want to thank the administration and faculty of John Carroll University for their invitation and generous hospitality; David and Margaret Mason, who welcomed me into their home and their family; and Joseph and Eileen Kelly for their special friendship. In addition, many friends who are artists, poets, and scholars read and commented on the essays as I was writing them, including Patout Burns, Kate Layzer, Lisa DiFranza, Doug Purnell, Charles McCullough, and Erling Hope. Several students and friends also generously offered to share their photographs as illustrations for this book, including Beverly Hall, Lisa DiFranza, Ann Vivian, and Gayle Graham Yates. Mary Hietbrink, my editor at Eerdmans, was an essential collaborator in the process of turning a set of lectures into a manuscript, and a manuscript into a material reality. My dearest colleague during my first years of teaching, Mark Burrows, shared the burdens and the joys and the dream of establishing a theology and arts program at Andover Newton Theological School. Finally, although I am grateful for all my colleagues in this field, I dedicate this book particularly to Wilson Yates, my mentor and friend, whose commitment, ardor, and perseverance in the effort to integrate the arts into theological education has changed the way we understand our work, our faith, and our world.

# 1    *Visual Art and Spiritual Formation in Christian Tradition*

Growing up as a Midwestern, middle-class American female in the nineteen-fifties and sixties, I was encouraged to explore the arts of all kinds. My mother pursued oil painting in our basement, and all three of her daughters took extra-curricular art, dance, drama, or piano lessons. (I often wonder, if I had a brother, whether he would have been encouraged in the same way.) My upbringing supported my continuing art studies in high school and college, and after graduation I went off to teach art in public school and directed plays as an extra-curricular assignment.

Perhaps because of my art-enriched environment as a youth, I found myself vocationally confused. Was teaching art the right career choice, or was art actually a way that I learned and looked at things in a more general way? I left teaching after one year, considered pursuing theatre professionally, but ended up attending seminary instead. My professional shift surprised my artistically oriented mother, but not my father or most of my teachers and friends. For just as I had been active with the arts in my formative years, I had also been pretty serious about youth activities at church and had discovered that I was fascinated by the religion courses that I was required to take in order to graduate from my church-related college.

Still not sure what to do with my life, after three years I left seminary and went back to art school, thinking that I had left something important behind. For the next five years I vacillated, torn between practicing art and studying theology, assuming that I had to choose between them. For some reason, I never understood that they need not be separate pursuits — that following one didn't have to exclude the other and that each might be an aspect of who I was and how I was formed. When I eventually started teach-

ing Christian history and theology, I tried to find ways of integrating these different sides of myself, finally understanding that the arts were the way I understood my world, and one of the ways I expressed myself.

Thinking back on my situation growing up, I realize now that the church environment that formed and nurtured my faith, while not exactly hostile to the arts, made only minimal effort to integrate any of them into worship or Christian education. Singing in the choir was the full extent of my way of being an artist in the church. We didn't have liturgical dance or chancel drama, and there was very little tolerance for visual art in the worship space of our spare, Protestant sanctuary. The arts belonged to the secular world and had a taint of self-indulgence, sensuality, or even frivolousness that made them feel out of place in the house of God. I grew up thinking that religious formation had more to do with my behavior, piety, or good works than it did with vision or passion. Exuberance was somewhat unseemly. Desire and beauty were temptations that we had to resist.

I tell this story because I suspect that many middle-class white Americans of my generation had similar experiences. I also realize that times have changed, and even the most staid churches are starting to incorporate art into their worship, programs, and teaching. This is all to the good, but I worry that too often art is perceived as a kind of "extra" offering, meant for those of us who can appreciate it or want to be involved, rather than something essential to the shaping of faith and religious experience. At the same time, we fail to notice how much we are already affected by the arts — or lack of them — in our religious contexts. The architecture of the church building, the stained-glass windows, the organ music, and the flower arrangements may be taken for granted instead of evaluated or challenged. But surely they have an impact on how we think about, image, and worship God. And if we begin to pay that kind of attention to how all these things together inform and affect our faith, we might begin to wonder how we could have gone so long without noticing. And once we start to notice, we cannot help but be critical as well as appreciative. We may want to make changes.

So I first want to address the process of looking at things and coming to understand how the act of looking itself can shape and form us into visually conscious people. I want to reflect on the ways, active and passive, that we notice our visual environment. Occasionally we are engaged viewers, but most of the time we are only vaguely conscious of what is around us.

When we are engaged, we are attending to the experience of seeing in a highly conscious way, and we are aware of our responses, perhaps even of the more lasting ways we have been affected by the engagement. When we are passive observers, we may not be so conscious of the ways that what we see reflects upon who we are. When we have a sustained encounter with a particular image, we may find over time that we have been even more deeply affected by it than we first realized. Such encounters themselves, depending on their quality and duration, will be part of our spiritual (and aesthetic) formation.

When we consciously attend to an object, especially an art object, we will have some kind of reaction to it. The response may be subtle or it may be strong. It may be positive or negative. We may be turned off, aroused, repulsed, delighted, or disappointed. We may be moved to tears, frightened, bored, or baffled. Our responses may be different from those of the person next to us. But no matter how we respond, we are slightly or significantly different for having had the viewing, or the hearing — for having paid attention. Maybe only a single atom of our consciousness has shifted; maybe a landslide has taken place in our souls. Indelible memories may be fixed or recovered. We may not be aware of much impact, or we may recognize that this was a significant moment. Still, something happens. The experience and our response often resist explanation in words, reminding us that we can know or learn things without the benefit of language. Our memories, even our ideas, are essentially constructed out of images and colors, spatial relationships, smells, sensations, and sounds, more than they are made of words ordered into sentences — even when we record and transmit them this way.

Some visual images seem to have a kind of power over us. They attract, repel, or puzzle. Unbidden by us, they may call attention: they "catch our eye." Sometimes *we* seek *them* out. Philosophers and theologians from Plato onward have known that we are drawn to the beautiful, delighted and shaped by our encounter with it, just as we are drawn to the curious, the ugly, and the grotesque. Whether what we see pleases, disturbs, calms, or delights, an apparently inanimate object can have an enormous magnetic power. If we engage it long enough, we may come to a kind of intimate relationship with it. It can thread itself through our memories, even if it only forms a background for them. Such relationships can shift over time. As we ourselves change, our experience of objects and images we have come to

know well changes too. Moreover, we also come to realize that others do not have the same experiences. Something that we find beautiful, they find ugly — or they may just not see things or understand what they see in the way that we do. We eventually come to appreciate varieties of taste — the challenge of difference — and learn from one another.

Once, when I was in Rome, I stopped into the Chiesa del Gesù, the mother church of the Jesuit order and a primary example of Baroque architecture. I like this church, but I don't love it, even though I have come, over the years, to appreciate certain aspects of the Baroque style. On this occasion, however, I met a young Swedish girl, about ten or eleven years old, who was absolutely enraptured. She turned to me and cried out (in English) "This is the most beautiful place on earth!" and went in search of a priest to speak with. I noticed her uncomfortable, even embarrassed parents standing at the back, probably wondering what she would do next. After all, they were only tourists stopping by for a quick look, not for a mystical experience. But these things happen. The image might surprise us. I have never forgotten the look on that child's face. I wonder if she has gone back since, and how she sees the place now.

Even though in this case the discovery was unexpected, the beautiful doesn't always catch us by surprise. Sometimes we seek out images and bring our particular perspectives to the act of the viewing, shaping us even as we are being shaped by the image. People wait in long lines to see the *Mona Lisa* in Paris, the *Last Supper* in Milan, or the latest blockbuster exhibit at the Metropolitan Museum of Art. Pilgrims make arduous and expensive journeys to a particular shrine, sacred or secular (fig. 1.1 on p. 5). We invest something in the experience well in advance, bring with us certain expectations and hopes, and arrive with a keen sense of the potential in that moment of actually *seeing*. Perhaps some of the most common experiences of this powerful relationship between viewer and object come not from the art gallery but from the liturgy. For instance, week in and week out, in a Roman Catholic mass, the Blessed Sacrament is consecrated and elevated for the congregation to see. On the Feast of Corpus Christi, the Host is processed through the streets of a city (fig. 1.2 on p. 6). Those who participate in these processions know that what they see is different from what a casual observer sees. To the outsider, the image has no particular significance, except as a kind of spectacle or curiosity. But to the insider, the vision is itself the goal, and it has a sacred purpose and dimension.

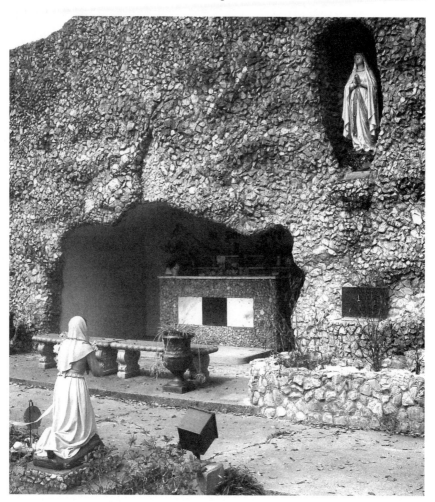

**1.1.** Grotto in New Iberia, Louisiana, representing St. Bernadette's vision of the Blessed Virgin Mary at Lourdes

In either case, whether we are "found" or actively go out looking ourselves, the act of seeing leaves a mark, some kind of impression. If we are disappointed or bored by what we see, if it does not attract us, if we do not find it beautiful or fascinating, we probably won't be very much affected by it and will go on to look elsewhere. But if we are attracted, fascinated, or even curious about the scene before our eyes, we will likely return to it, if only in memory. And this will begin to shape us in small or significant ways. But,

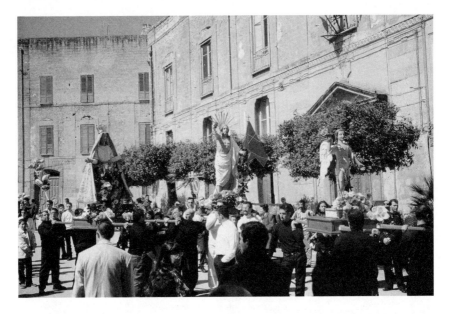

**1.2. Easter procession, Castelvetrano, Sicily**   Lisa DiFranza. Used with permission.

we may ask, what or who initiated this kind of seeing? Surely, even when we set out to see something in particular, we cannot predict or control what will pass before our eyes. To a certain extent we will always be passive observers, subjects who do not choose what we see. Once we have seen, we cannot erase the more powerful images from our minds without great difficulty. Thus it happens quite often that seekers who think they know what they're after are suddenly taken down a different path, drawn by a vision of some kind that powerfully affects them in ways they had not expected.

## The Formative Power of the Beautiful

The subject of "beauty" has been much studied through the ages, in particular in writings on philosophical and theological aesthetics. To many people the term, at least at first, refers only to qualities that make something externally pleasing or lovely to the eye, so they miss the active agency — or force — of beauty. An alternate term, "attractive," expresses energy and power. Ancient as well as modern philosophers, who have written on the

6

power of a beautiful object to attract us and cause us then to ascend to higher (or more profound) knowledge, were not primarily interested in external loveliness or — even worse — prettiness. Philosophers like Plato or theologians like Augustine spoke of the human response to beauty as a directional energy that motivates and focuses the viewer. Such observation is not simply *seeing* something but deeply engaging it at many levels.

Our attraction to the beautiful object is a directional pull, drawing us toward itself, and thus it serves as both inspiration and guide. In Plato's *Symposium*, Diotima, Socrates' muse, has him consider the subject of love. The true lover desires only what is good, true, and beautiful. To arrive at these objectives, however, a person may contemplate a beautiful object or individual in disciplined stages. Attraction engenders love, and love leads the person forward toward truth in higher and higher stages, until the ultimate goodness, truth, or beauty is glimpsed. The attractive object is both model and impetus — it contains elements of that ultimate beauty which draws us toward itself at the same time that we ascend.[1]

According to Plato, humans long for union with the ultimate goal of our contemplation — the vision of the true Beauty — the Divine, which is the source of the reflected beauty that we see. Our longing for this union leads to action. Beauty does not passively work on us but stirs us up to strive for this union. While we strive, we are transformed: as we progress toward the goal, we are gradually shaped in its own image. It's not like a magical spell, changing us in a single "poof." The external eye is attracted to an external beauty at first, but subsequently the inner eye recognizes the universal quality of beauty itself, and the initial attraction turns to love. Attraction initially and finally love provide the energy that draws us onward and upward, but the aim is perfection, a combination of both goodness and truth. In this pursuit, we are taken outside of ourselves and oriented to the "other." The beauty that we first see, then seek, is beyond us, even though we are born with the innate ability to recognize it (since we also possess it in some measure).

Five hundred years after Plato died, these ideas were still in circulation. Plotinus, the third-century Neoplatonist, wrote a mystical treatise on beauty, urging the soul to know the source of its own inspiration: "Let us, then, go back to the source, and indicate at once the Principle that bestows beauty on

---

1. Plato, *Symposium* 210-212.

material things. Undoubtedly this Principle exists; it is something that is perceived at the first glance, something which the soul names as from an ancient knowledge, and, recognizing, welcomes it, enters into unison with it.... This, then, is how the material thing becomes beautiful — by communicating in the beauty that flows from the Divine."[2] Thus, for Plotinus, as for Plato, progression lies first in the attraction of the object for the observer, next in the relationship that emerges between the two, and finally in the recognition that both attraction and relationship are dependent upon the ultimate source of beauty itself. Beauty is not the goal or highest reality; its source, the Good, is. Our aspirations are, ultimately, toward the Good.

Augustine was greatly influenced by these ideas, and he reworked them, giving them a Christian interpretation. For Augustine also, the particular beautiful object delighted the eye and attracted the human affection to itself. Spiritual ascent meant moving away from the starting point (the material object) to the immaterial divine source. Augustine agreed that since the beautiful object reflected the essential beauty of the divine, it also could be said to participate in it. By sharing in this beauty, the object was able both to awaken desire and to provide an intimation of the ultimate goal. This was its own particular good, to motivate and to show forth that goal. Moreover, as Augustine wrote, the observer not only loves the beautiful object but also instinctively begins to imitate it, gradually becoming both good and beautiful while striving for that union with the source of all goodness, truth, and beauty.

But for Augustine the original attraction of the beautiful was the evidence of divine grace, irresistible, magnetic, and salvific; it was God-initiated, not human-willed. The power of our recognition stems from the fact that we are created in the image of God, and so share in a marred but original beauty. However, Augustine would add, we need to transcend attraction to beautiful things in creation and focus on the ultimate source of that beauty. Otherwise we are misled or seduced by something that finally cannot content us. Beauty does not satisfy but draws us. It intimates, evokes, and draws us in or out. The model thus acts as a kind of guide, but we must not stop there; we must recognize the quality of beauty that it shares with other beautiful things in the world, and then with the transcen-

2. Plotinus, *Enneads* 1.6.2, in *Plotinus: The Enneads*, trans. S. MacKenna, 3rd ed. (London: Faber & Faber, 1956), pp. 57-58.

dent ideal of beauty itself. The movement from the particular to the general and finally to the ideal is what keeps us from falling into idolatry. Remaining attracted only to the created things of this world can only frustrate us, since they are finite and will fail us as themselves alone.[3]

As observers, when we turn toward the beautiful object and recognize that its beauty is partly a revelation of the divine, we respond with gratitude as well as delight. The beauty in ordinary things is one of the ways God chooses to be revealed to us. Thus we are doubly blessed, by vision and by motivation, to become more beautiful and good ourselves. This has profound ethical implications. Our appreciation of beauty draws us not only toward beauty but also toward the good that is inherent in the beauty, and without which it could not be beautiful. We become more deeply appreciative of what this beauty is by virtue of what it shares. Out of our appreciation, we are moved to change, so as to be worthy of this great blessing. A sentence in Pope John Paul II's letter to artists hints at this: "Beauty is to enthuse us for work, and work is to lift us up."[4] I would offer a slight revision: Beauty enthuses us for works that will lift us up.

Yet, although the ideal of beauty is shared by all beautiful things, and is perceived through, reflected in, and modeled by them, the term actually transcends them and defies definition. Even identifying a set of shared characteristics of beautiful things is beyond our power. We may say, "*This* is beautiful," but we cannot exactly say why. The quandary causes us to realize that beauty is not a single, external quality (or some combination) but an internal and mysterious one. That realization causes us to long for what is beyond the earthly or individual: for transcendent, ideal beauty. When we try to explain why certain art is beautiful, we may fall into a particular quandary, since some of the greatest art we may want to consider might not be considered conventionally beautiful, even by the terms of our own sociocultural location. Paul Tillich once took up this problem in a lecture he gave at the Minneapolis Institute of Art in 1952: "If 'beautiful' means a creation whose harmonious forms produce immediate pleasure, only a few and very questionable artistic styles are concerned with beauty. If, however, 'beautiful' means the power of mediating a special realm of meaning by

3. Augustine, *Confessions* 10.33.49-50, in *Saint Augustine: Confessions*, trans. H. Chadwick (Oxford: Oxford University Press, 1991), pp. 207-8.
4. John Paul II, *Letter to Artists* (Chicago: Liturgy Training Publications, 1999), p. 5.

transforming reality, art is bound to be beautiful."[5] When I read this, my own thoughts turn immediately to the cross, an image of terror and human suffering that for me is also an essential symbol of transformed reality.

It is here that beauty demands our attention, time, and effort. Often the thing that is offered to us as "beautiful" might baffle or confuse us. It might seem ugly, foreign, incomprehensible, or even foolish. The encounter bears no resemblance to Augustine's sublime experience of delight. But some things take time. As we get to know and understand them better, we begin to see their value, and then their beauty — a beauty that lies neither in an outward and obvious loveliness, nor in the ability to produce a safe and recognizable image that lets us stay in safe, familiar territory. As we challenge ourselves to become ever more experienced and sensitive observers, we can find the beauty in these unexpected places, like children whose tastes must develop so that they might enjoy the sharp or the sour as well as the sweet, or like the discerning reader who appreciates the truth of a powerful description more than the pleasure of a happy ending. True beauty, as we have already said, must also participate in the good and the true. Without these, what superficially appears as beautiful cannot last and will not transform our work, our perceptions, or our relationships.

## Making Art: From the Inside Out

Seeing (in its broadest and deepest sense) imprints us and changes us. It may even become the way we think. But *seeing*, however active or passive, may not be the only way of engaging beauty or being shaped and formed by art in the visible, external world. We are not only viewers of art; we are also makers of art, engaged with the creation of art objects ourselves. Each act of creation is a spiritual exercise, strengthening or honing us in particular ways, making us more and more into who we shall become and how we understand ourselves in relation to the rest of the created world.

Some time ago I was speaking to a group of seminary students, trying to explain how I understood the connections between visual art and theology. I began by drawing a parallel between God's creative acts and our works of

5. Paul Tillich, first lecture to the Minneapolis Institute of Art in 1952, "Human Nature and Art," reprinted in *Paul Tillich on Art and Architecture*, ed. John Dillenberger and Jane Dillenberger (New York: Crossroad Publishing, 1989), p. 20.

artistic creation. That seemed good in theory, but I realized that the parallel wasn't connecting to actual experience for most of the students in the group. They didn't think of themselves as artists or as creators. Most of us are like these students. We believe the best we can do is appreciate art, not make it. Real "artists" are often as intimidating as they are impressive, held up in public regard as specially gifted persons capable of feats beyond ordinary human capacity. In almost every context in which I have taught art (or about the arts), I have heard this kind of apology: "I can't draw a straight line." And I have wanted to respond that that's just fine. Straight lines exist only in mathematics. Creation is full of crooked, broken, or curly lines.

As young children we were given crayons and drawing paper, and we drew, not necessarily straight lines. Pictures were a language we understood before we could read and write. Images were modes of expression and communication. Colors and shapes carried ideas and feelings. The goal wasn't to mimic the external world but rather to interpret it. Our books were filled with pictures. But at some point we left the world of images and moved to the world of words, and our books were filled with text and, occasionally, maps, diagrams, and grainy black-and-white photographs. That meant we had grown up.

At about that same time, we began to see art as something constrained and imitative. We were meant to make our pictures look like everyone else's, or to replicate a magazine photograph, or paint a recognizable likeness. This, we were told, was "art." Some of us were more skilled than others at this and were sent on for special classes, segregated as "gifted" in a particular way. The others got the message that they "weren't artists" and eventually stopped trying to express ideas or feelings in visual ways. Imagination was less important than analytical ability. Art became something that we *couldn't do*. After all, if it was something that we could do just as well as an artist, it surely couldn't be *art*.

Based on this socialization, few of us consider our adult work to be "creative," let alone "artistic." On the one hand are the "mere" amateurs who pursue art as a hobby; on the other are the select and highly trained professionals who have unusual natural abilities, much like professional athletes or musicians. The latter group often evokes wonder as much as admiration, as if the ability was the result of a kind of magic, something strange and unimaginable to ordinary folk. Given this, I realized that asking any large group of "ordinary folk" to participate in making visual art could

be quite stressful. It would be like suddenly asking them all to play an instrument they had hardly ever seen before — or to sing a solo, turn a pirouette, or run a mile. Some would do fairly well, but others would feel self-conscious and embarrassed.

With these seminary students, I decided I had two simple goals. The first was to demonstrate the important but neglected act of observation. I would simply ask the students to attend visually to objects in the external world over a fairly long period of time. This could mean spending an extended period examining a single object in space, noting the complexity of its shape, the subtleties of its colors, its texture, the shadows it cast, and so on. The second was to re-awaken an interest in expressing ideas through visual images, done with the hand (however clumsily) by reproducing that observed object with paint on paper. This wasn't meant to be like a drawing class; it was meant to be something more like a scientific experiment — careful observation and precise recording. Once we finished the exercise, we could look at a variety of great paintings in good reproduction. We could begin to understand how the artist sees, and how an artist's imagination plays with the basic material of observation.

I suppose this is why I think everyone (maybe theologians especially) should take at least one class in life drawing. The gain is something that we could call "somatic knowledge." The whole body engages in the work of learning, evaluating, and communicating in this wordless mode. We see things with our eyes, think them with our hands, and extend them into space by means of image. In fact, the theological basis of this way of knowing and speaking is the Incarnation. God did not self-reveal in the words of Scripture alone; God also appeared in a visible, physical form, with weight and mass, color and texture. The notion that theological insight can come through an artist's creative expression is justified at the very center of our confession of faith (fig. 1.3 on p. 13).

This is not to say that everyone needs to be an artist, but only that some recovery of the skills of observation and visual expression is vital for a full range of insight and communication. The same could be said for training the ear to hear sounds and tones as musicians do, or to become more kinesthetically aware and expressive, as dancers are. These skills stretch the ways we receive, process, and transmit our discoveries. They bring us closer to deep and full self-knowledge as we journey toward enlightenment. We need to become visually literate as much as we are verbally literate if we

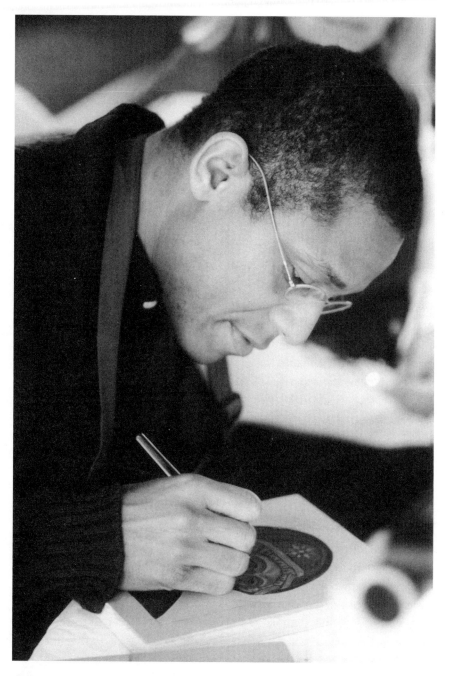

**1.3. Icon writer Christopher Gosey at work**   Beverly Hall. Used with permission.

want to be more fully aware, insightful, and receptive to messages from both the secular and the sacred realms.

I want to raise a caution here, however. Sometimes when art is promoted as a way to spiritual enlightenment, the proponent seems to want to bypass or even denigrate the cognitive aspects of this process. Art is presented as a way of "getting out of one's head" and discovering "truth" in some purely mystical or non-intellectual sense. I think this idea can be dangerously misleading. The artist's work is an integrated process that engages the mind as much as the eye and the body. Images are ideas, not simply reactions or emotions. Visions may appear to us from outside (either from inspiration or observation), but we receive and shape them and return them to the outside in a form that can be shared with others. It serves no good purpose merely to privilege image over word, even for the sake of counteracting the dominant modes of learning and communication in contemporary Western culture. Such dualism overlooks the greatest works of literature and poetry, which rely on words to shape and express the images that appear to our imaginations. Making art is an arduous, disciplined, and profoundly cognitive process, not the result of a moment of unconscious or mystically channeled genius.

The images always originate outside of ourselves, either from observation or direct revelation. Usually some object in the external world inspires the idea or stimulates our imagination. We could say, "Something just *struck* me." The images or ideas we receive do not appear *ex nihilo*, nor do the ways we reshape them, according to our own inspiration, into art. The incoming data resonates with something already in our minds or our memories, even if we are unaware of it. We make *connections* between things we have always known and those things we see, hear, or otherwise experience with our senses. We are like Adam and Eve, naming the animals that already live in the Garden. However, from a Christian vantage point, the incoming data is not simply random, like the landing of a meteor. The inspiration is a gift of the Spirit, and we are meant to attend to it. Our imagination is a receptive organ, and our imaginative work is, therefore, a way we encounter and engage with the divine. And yet the artist's task is not merely to record but also to present the result of the encounter as it is shaped by that *disciplined* imagination. Art's purpose is not to imitate life. Art's true function is to externalize, shape, and present a particular view of life and thus to achieve its own reality.

14

The common element between the art we observe and the art we make is our imaginative involvement with them both. By this I mean that one can be engaged in a kind of dialogue with the thing being observed, or between the thing imagined and that which is produced. In each case the mind takes in the object or idea and forms it again in the imagination as well as "in life." Of course, nothing that we see or hear makes any sense unless it makes a connection with our memory and fundamental experience. The way we understand or evaluate what we see is filtered though the accumulation of our essential knowledge and experience and then stored in our minds as memory. Since our imagination draws its raw materials from memory, even though it organizes or shapes these fragments into new forms, they bear the imprint of the familiar.

### From Memory to Form

Augustine colorfully described the human memory as a "huge cavern" containing a variety of corners and crannies where images and ideas are stored to be recalled as needed. He marveled at the freedom and power of the imagination to bring things back to the senses at will — the smell of lilies or the taste of honey — without the actual sensory experience. He noted that he could recall the sound and image of the sea, and the feelings of fear and love, and an almost endless list of other things. Augustine thought of memory in the same way as beauty — as essentially a stimulus to ascend, to rise above the sentimental recollection of things to the source of all. But, he admitted, he also wondered, "As I rise above memory, where am I to find you [God]?" He believed that without memory humans could not even begin to — much less continue to — seek after God.[6]

Rudolf Arnheim, the twentieth-century philosopher and psychologist of art, had a similar way of speaking about memory, yet without the religious reference:

Memory is a much more fluid medium than perception because it is farther removed from the checks of reality. The result is a storehouse of visual concepts, some clear-cut, some elusive and intangible, covering the

6. Augustine, *Confessions* 10.17.26.

whole of an object or recalling only fragments. The images of some things are rigidly stereotyped, others are rich in variation, and of some we may possess several images unwilling to fuse into one unitary conception, e.g., the front-face and profile images of certain individuals. All sorts of connections tie these images together.[7]

If we completed his idea in this context, we might say that the work of the artist was to tie these images together, to make the connections between the images in the memory, the creative imagination, and the essential skills of expression that give an external existence to all of these. Imagination is the tool, then, that works on the "stuff" of the memory and gives it form. A famous passage in Shakespeare's A Midsummer Night's Dream captures this idea perfectly:

The poet's eye, in a fine frenzy rolling,
Doth glance from heaven to earth, from earth to heaven;
And, as imagination bodies forth
The forms of things unknown, the poet's pen
Turns them to shapes, and gives to airy nothing
A local habitation and a name.                    (V, i, 12-17)

The artist not only reproduces what is in the memory but also uses it as a means of conveying another envisioned reality. This is the imagination's work — to begin with the familiar as a starting point, and then to focus, shape, twist, or even explode it into something new — but yet perhaps keeping enough of the truth of the original so that others might find their experience there too. That's why an encounter with a work of art will sometimes elicit the reaction of "Yes, that's it! That's precisely it!" But the "it" defies explanation. As when we receive a sacrament, the unexpressed idea is made known through the ordinary material, the vast and invisible through the limited and visible. The artwork is entirely and uniquely "fit" for the truth that it tells.

Making art is a creative act that draws its inspiration from the external world, incorporates the images in the memory, draws upon the active

7. Rudolf Arnheim, Visual Thinking (Berkeley and Los Angeles: University of California Press, 1969), p. 84.

mind, and produces a visible image that points far beyond itself. In other words, it is a type of spiritual formation. Because of our environment, our memories, and our visions, we are constantly in flux: our formation is continual. Creation and formation are a process; we don't suddenly arrive at our completion (at least not in this life). Artists are restless people, always at work, doing the same thing again and again, or moving on to the next project. Their discoveries are not endings, only openings. The opening chapter of the book of Genesis recalls this idea of restless repetition in the creative process. In the beginning God created the light and the darkness, and saw that it was good. And so God created again — a second day, a third, a fourth, and so on. The text itself has a rhythmic repetition: "And there was evening and there was morning, the first day."

G. K. Chesterton mused on this divine repetition, noting God's never-ending pleasure in the sunrise. Seven days is one thing, but God has seen the daybreak for — what? — millions of years? What might look to some like an endless, boring pattern is, Chesterton asserts, just the opposite — the routine is not evidence of lifelessness, but is rather "a rush of life. The thing I mean can be seen, for instance, in children, when they find some game or joke that they especially enjoy." Like a child on a swing, or a dog with a ball, God can "do it over and over and *over*" and each time find it a thrilling experiment. "It is possible that God says every morning, 'Do it again' to the sun; and every evening, 'Do it again' to the moon."[8] Each day is new; each time is actually the *first* time.

This God-like delight in the work, even when it seems repetitive, is where I believe the creative life and the spiritual life find their common joy. For however hard or frustrating or physically taxing it is, true artists are unable to give up striving for "the perfect expression." In retrospect, the striving itself is the source of the deep joy and satisfaction, far more than the result. With each success, the artist will set herself or himself a more challenging task, as if satisfaction or achievement were the ignition rather than the brake. We are inspired to push on, not to stop and rest on our laurels. Sabbath is still ahead of us.

This is the lesson of the arts: to discover the activity that we do simply for itself and for no other reason, although along the way we find delight

---

8. G. K. Chesterton, *Orthodoxy: The Romance of Faith* (New York: Doubleday, 1959), p. 60.

and make discoveries that propel us forward. It seems to me that the nearest approximation of the angelic life is finding the art that we will *want* to practice for eternity. Art, after all, isn't something we merely do; it is the way we live and who we are. We must find a true delight in certain activities for themselves alone. We also find the activities essential to who we are, to our formation as persons of faith, to our expression of meaning, and the motivation for extending ourselves into the world in works that, as John Paul II would say, "will lift us up."

The drivenness that I have just described comes both from a need to put something "out there" for others to see, and from a desire to see and understand for ourselves what it is that we have encountered and how we have been formed. I write because I want to get the ideas in my brain organized and bring them into the light for examination. Art is an activity that gives form to the abstract, brings it out into the external world, so that it may be seen and judged. We rarely start out knowing how it's going to look at the end. Picasso was reported to have said, "If you know exactly what you're going to do, what's the use of doing it?" Once the ideas are where I can *see* them, I can evaluate, polish, and even re-*think* them. Before that, they are a kind of chaos banging around in my head that aches to be disciplined, a clamor that wants to be given form, random thoughts that yearn to become structured and sensible arguments. Often I make (or say) things I had not planned. I didn't even know that I had thought them.

This requires and also produces self-disclosure, first to oneself and then to others. It's also risky — communicating with an audience who might or might not understand. By making their ideas visible, artists actually see them in a new way, as if hitting the light and air condenses them into a concrete and independent reality. If these images or ideas were kept inside, rattling around in our brains (like Augustine's cavern), we would become terribly anxious or profoundly depressed. Once we begin to externalize them, we see things we had missed or overlooked — and so the clamor starts all over again, and we realize there is still more to know, to learn, to express. The work, like the Creation, is never done.

Sometimes the discoveries happen in stages or in fragments, like poems that refract images in our memories and present them to us in new and surprising ways. The figures or forms or colors of a painting can become a concentrated nugget of a recognized truth. The melody line in a symphony is the central thread, woven through the rest of the music. As Matisse knew,

a dancer's single gesture can capture the essence of the whole dance. And as we see it all again, see it with new clarity, we recognize something that has now become familiar, and we can't believe we didn't know it all along. We have it now as a part of our operating system, a part of our vocabulary.

## Art, Faith, and Formation

Taking up art is risky, just as it is risky to change our lives or fall in love. For it to work, we must give up all control and allow ourselves to be vulnerable and exposed. We give up the familiarity of the status quo (whether comforting or stifling) and take a chance on the unknown. The gamble is like a leap into the dark, but it's only through such leaps that we will grow. Maybe it's best if we take it slowly and progress cautiously, rather than rushing forward all at once, just in case we overestimated our powers. But eventually we will find ourselves challenged to look and to leap. To risk the gaze, and perhaps be changed into that on which we gaze. We come to know that the thing we see is not the truth itself but a means for our encounter with the truth. A verse from Paul's Second Letter to the Corinthians says this better: "All of us, with unveiled faces, seeing the glory of the Lord as though reflected in a mirror, are being transformed into the same image from one degree of glory to another; for this comes from the Lord, the Spirit" (2 Cor. 3:18).

Finally, the way we are formed through art is more than just our having lots of "art experiences." We also need to detach from and transcend the experience so that we can evaluate its actual *content* and how it fills its role as message or model; how well it tells the truth. We need to wonder whether and how we are changed or moved to change through the experience of art. Have we been helped or harmed? What kind of power does the art have? What is the "good" that we seek? How can we evaluate our encounters from a theological and ethical perspective? In a discussion of formation, we must consider the dangers of malformation.

Today most of us live in an art-saturated (or, better yet, media-saturated) environment. Earlier generations lived otherwise — in worlds that saw art as different from nature in part because it was a human interpretation of nature and in part because it was a much smaller subset of daily experience. Nature dominated; art was out of the ordinary. Today we live in a culture-dominated and image-saturated world. In one form or an-

other, music, visual art, and theatre are ubiquitous; they are both the foreground and the background of our existence. It's difficult sometimes to find silence or empty spaces. For us at this time, art is no longer contrasted to nature. Instead, it is contrasted to what *pretends* to be art but actually exists for a separate purpose. Although television producers, Hollywood agents, and advertising executives insist that they are only responding to public demand, we also know that the public's demand, or desire, is easy to manipulate and difficult to elevate. So perhaps we are not getting what we want but getting what someone else *wants* us to want. Our eyes and ears are flooded with messages and images that become so familiar that we mistake them for memories and confuse them with truth.

Criticism of the content of art is not just about making value judgments but about being aware of another aspect of art's power — imitation. If we are conscious of the power of the visual image to encourage mimetic behavior, we will see that we can't afford to be passive or uncritical viewers. What we see (or listen to, or read, or watch) even in passing is part of what we become, even when we aren't fully aware of it. Most of us have seen this demonstrated when children imitate the characters they see on television or electronic games. I have noticed that my own students remember the pictures I show far longer than the words I say or read to them. They have made "an impression." Eight hundred years ago, the bishop and canon lawyer William Durand made the case that visual images stayed in the mind far longer than words. He pointed out that "paintings appear to move the mind more than [verbal] descriptions." For while deeds portrayed visually are placed directly before the eyes, stories told are recounted as if by hearsay, "which affects the mind less when recalled to memory."[9] And so, if we recognize that our children will imitate art, we need to think very carefully about the art we present to them and the power it has over them.

The fashion industry, for instance, shapes our idea of style — sometimes this is called "trend-setting" — and in the end, a particular style is so thoroughly taken for granted that we aren't even aware of our own mimetic behavior. It's not just what we see, but how it is presented to us — as iconic, or meaningful, or even mythic. Something that is packaged and sold as beautiful or desirable suddenly becomes so. The point of commercial art,

9. William Durand, "Rationale of the Divine Offices," selection excerpted from *A Documentary History of Art*, vol. 1, ed. E. G. Holt (New York: Doubleday, 1957), p. 123.

whether we call it advertising or persuasion or marketing, is to associate a particular set of images with certain values — success, health, happiness, and so on. If it works, we incorporate these images into our unconscious value system and hardly even question them. But if we remember that imitations are secondary things, meant to guide us or inspire us toward the truth but not to substitute for it, we may avoid confusing objects with values or beautiful things with beauty itself.

Like that activity we do purely for the love of it and for no other secondary reason, art that is true has no other goal than to lead to its higher reality. It can't be a tool of the marketplace, with a particular aim of selling a particular product or idea, however well designed or attractive those forms of commercial imagery might be. Art might reflect an artist's values or commitments, and it might be intended to change perspectives or deepen insight, but true art is open-ended. Different responses are expected, encouraged, and allowed. Each experience, encounter, or interpretation is valid and spontaneous. Art that leads the viewer to draw only one conclusion or that is designed to elicit a particular response from the viewer is not actually art but a "sign," a simple message, advertising or propaganda (fig. 1.4 on p. 22). An image that prompts me to buy a particular product, or to vote for a certain candidate, or even to perform a public service might be a good or a bad thing, but it is not art in the true sense.

While it is true that artists expect no single response to their work, they certainly produce in order to elicit responses, and their works of art of whatever kind are meant to have an effect on viewers. These effects change us, contribute to our continuing formation. This should produce results that we can see in the same way that inner grace is shown forth in works: in and through action. Not the action that motivates us to redecorate the house or to lose weight or even do a particular good work, but the action that emerges from a changed viewpoint, a different attitude, or a heightened awareness of some aspect of life. If we reflect upon something of beauty long enough, we should begin to be like it. If we study an image of horror or suffering, we will be moved to rage or pity. If these are only passing responses, we will not be truly changed. But if we are changed at all, if the images take root in us, we will act differently in the world. The things we value, the activities we pursue, the ways we *see* the world will be altered, and so will we — sometimes instantly, but usually gradually. This is one of the ways I now understand the childhood expression "make believe."

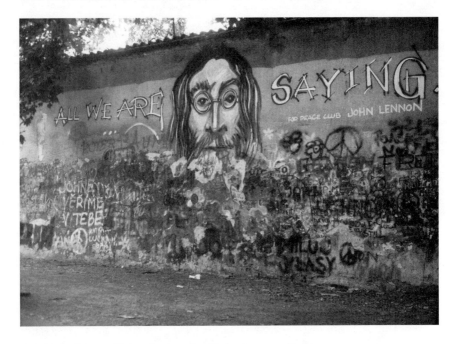

**1.4. Wall with graffiti and portrait of John Lennon, Prague**

After all, we are not changed by a work of art as if it had an independent existence or power apart from our engagement of it. We are changed by how and what we think about it as we study it and reflect on the experience later. We don't make instant and unchanging judgments of what we see or hear. We learn to discriminate, to recognize, to understand the beauty in art over time and experience. Art takes time, and formation is gradual. Not all artistic creations are obviously or equally beautiful to different viewers (or audiences). Most of us have to be helped to see, guided or taught how to look. And while some people seem to be born with a "good eye," others cannot see or understand what all the fuss is about. The eyes of different beholders often disagree about what they see in front of them. Moreover, our judgments themselves are subject to change. As we grow more sophisticated, more experienced, or simply older, we learn to be better viewers. We become both more open to the new as well as more discriminating about the familiar — telling the superficial, the bland, and the banal from the fine, the lasting, and the profound. Training, practice, and discipline are required.

## Active Seeing

When it comes to merely "seeing" what is in front of our eyes, we rarely stop to analyze or evaluate. We passively glance and forget, or remember what we had expected to see but not what we actually saw. Beginning artists or musicians realize that they must learn a new discipline of careful observation or listening. They must forget what they think they hear or see and pay attention to what is actually *there*. Drawing class is an exercise in looking. Colors are never consistent fields of a single hue, for example. Viewpoint distorts proportions, and shadows hide things we know are present but can't actually see. At the same time, true seeing is also a process of incorporating what we know in our heads or hearts with what we experience with our senses. The way our belief about things changes the way we experience them in sensory terms cannot be dismissed, for this is the basis of interpretation, the driving energy of expression, and the fountainhead of meaning.

In a short article on the nature of image, Margaret Miles addressed the difference between active viewing of static religious pictures and passive viewing of film or television. Although her argument could as well be applied to the difference between active and passive viewing of any visual art (moving or not), she is particularly aware of the importance of instruction in the visual observation of fixed images, for in this case the viewer must engage imaginatively with the image, supplying the missing details and filling them with meaning: "It is ultimately not the image itself but the viewer's committed and trained labor of imagination that connects the devotee to the religious painting. It is neither the subject nor the style of the painting that makes its use religious, but the viewer's conceptual and emotional investment in it."[10] From this Miles goes on to make a convincing case for such training. She makes the point that we need to become acutely aware of how what we see forms our values and shapes our perceptions in the larger sense.

This is what makes museum-going both exhilarating and tiring. On our best days we don't just pass by, barely noticing things; we pay attention and really engage them. Similarly, when we really listen to music (versus having

10. Margaret Miles, "Image," in *Critical Terms for Religious Studies*, ed. M. Taylor (Chicago: University of Chicago Press, 1998), pp. 168-69.

it on for "background"), we can find the experience exhausting or highly energizing. And one session is never enough. We decide to make the effort to go back and look or listen again and again, to really begin to know the work and to understand its possibilities and depth. We need to live with it, to experience it over time, until its familiarity begins to make it seem less mysterious or remote and more generous and meaningful. When this happens, it's almost as if we've broken through a language barrier and made a friend from a remote culture. Even the most disturbing images can become comforting; the ugly can become lovely if we take the time to get to know it.

John Cassian, a fifth-century teacher of the spiritual life, described a monk's chanting of the Psalms in a way that illustrates this authentic and deeply personal encounter with art:

> He will take into himself all the thoughts of the Psalms and will begin to sing them in such a way that he will utter them with the deepest emotion of heart, not as if they were the compositions of the Psalmist, but rather as if they were his own utterances and his very own prayer; and will certainly take them as aimed at himself, and will recognize that their words were not only fulfilled formerly by or in the person of the prophet, so that they are fulfilled and carried out daily in his own case.[11]

Cassian did not mean or desire that his monks should jump right from the Psalms to their own personal lives and find the meaning there in a kind of superficial way. Rather, he intended that daily praying of the Psalms would form their religious sensibilities and help them to be aware of God's presence in the particularities of their own lives. In other words, Cassian's advice is to pray not "as if" but "until" the words of the psalmist become our own.

Learning to look with discernment while retaining openness to the unexpected or the miraculous is the initiation of a visionary life. As with the disciples on the road to Emmaus, the realization of truth is often a matter of finally *looking* and then recognizing. The complicated relationship of viewer and object or of visionary and vision is a careful balance between activity and passivity, between concentration and focus on the one hand

11. John Cassian, *Conferences* 10.11.5, in *John Cassian: The Conferences*, trans. B. Ramsey, Ancient Christian Writers, vol. 57 (New York: Paulist Press, 1997), p. 384.

and receptivity or responsiveness on the other. We can select something to look at and study it with deep absorption, or we can catch a glimpse out of the corner of our eye and find ourselves attracted wholly without our intention. Either way, we have the possibility to become engaged with or attached to what we see and to be aware of the impact it might have upon our lives. No matter how hard we try, we are never entirely unaffected by the world around us — its colors, sounds, smells, tastes. We may, however, choose to be, learn to be, practice at being more conscious of these things. We may allow ourselves to be enriched, edified, and inspired by them and the way that they alter our existence, or rather our perception of our existence. This is the role of art — to shape and present to us a vision crafted of experience, memory, and truth.

And so we have come full circle. All of us, I believe, have been formed by the experiences we have had, but especially by those we have been most engaged with for themselves alone. The love and delight of these is also what draws us in to the practice of art. The practice, not the result, is the way we participate in creation itself, whether the practice is making or viewing. Acting as spectator or creator engages our bodies, our senses, and our imaginations. We come into contact with an inanimate "other" and fill it with life, receiving knowledge, meaning, and love in return. The knowledge is about art, about ourselves, about the creation, and finally about God. The meaning is our formation in faith that leads to action for good, and the love is the vulnerability we have to its power and the delight we experience.

By virtue of this imaginative encounter, the viewer becomes a co-creator with the artist. She recognizes, I think, that the physical connection of the artist to the object is basic — not unlike that of a parent to a child. The artist — the parent — and the viewer both take responsibility for bringing the experience to birth and for its subsequent life in the world. Contrary to the romantic view of artistic creation as instantaneous expression of genius, this is almost always an agonizing and difficult process. I know few artists who produce in sudden, unedited bursts, and equally few viewers who immediately see all there is to be gained in the image. To participate in the making of art is to participate in God's creativity, but only in the Platonic sense — we understand it better but come nowhere near its perfection. We gain in wisdom.

The love of and the making of art are humbling and emboldening at the same time. Artists offer their creations to the world, knowing better than

anyone else the flaws and pretense of the offering. Viewers must risk the journey on which art will take them. But in its freedom the imagination transcends earthly restraints. Artists and viewers risk, dare even to envision eternity — to see the face of God and live. Like Moses, they are driven to the risk, engaged in it, enlivened by it, and thoroughly enraptured by it. There is no other reason for it, except to love and to live through the work itself. Art isn't just what we do. It's how we live and who we are.

# 2 Visual Exegesis: Sacred Text and Narrative Art in Early Christianity

Rome's Christian catacomb of Peter and Marcellinus contains some of the earliest examples of early Christian art: wall paintings that date to the late third century. One of these, on the dome of a small burial chamber, shows an image of a shepherd and sheep enclosed by a red circle. Circling slightly below him are four figures, their hands raised in the ancient gesture of prayer, interspersed between episodes from the story of Jonah. In the first of these scenes, Jonah and his companions on the boat to Tarshish are caught in the tempest; in the second, Jonah is being tossed overboard into the waiting jaws of the sea monster; in the third, Jonah is being spit out again; and in the fourth, he reposes on dry land, under a gourd vine (fig. 2.1 on p. 28).

These figures — the shepherd, the praying figures, and Jonah — are among the most common subjects of early Christian art in both sculpture and painting. They often appear together in compositions that add other figures: peacocks, a seated philosopher, a fisherman, and so on. The image of Jonah is different from the other two, however, because it refers to a particular scriptural text — a story that we have been told. The Jonah iconography is also unique because it is the *only* narrative image from the early period commonly presented in sequential scenes, like a modern comic strip.

A modern viewer looking at these paintings might not immediately identify the four images as scenes from the story of Jonah. Most of us are more familiar with Jonah portrayals like those from the illustrated Bible storybooks of our childhood, which show Jonah sitting in the belly of a whale, wearing the clothing of a sailor or a prophet (almost never naked, as he appears in these early Christian paintings). The images that we see here are different, distant, and ancient. They are rough sketches on the walls of a

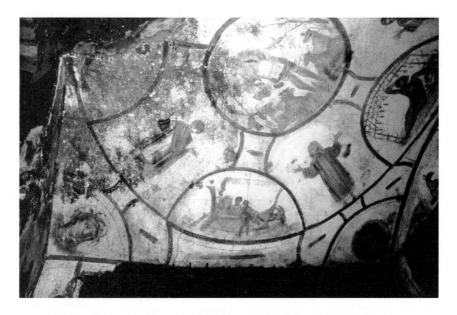

**2.1. Jonah scenes on the dome of a cubiculum in the Catacomb of Peter and Marcellinus, Rome** International Catacomb Society, Estelle Brettman, photographer

third-century tomb that aren't particularly decorative or even especially clear. Once we recognize the pattern of the images and their basic composition, however, we can immediately recognize them as portrayals of Jonah. And we will discover that there are a lot of them.

Art historians have long noted that this composition borrowed certain familiar elements from contemporary Roman (non-Christian) models, including a certain kind of sea creature with a twining tail. Jonah's consistent and unusual pose, reclining under the gourd vine on his left side with his right leg crossed over his left and his right arm bent over his head, is identical to that of the classic representation of the hero Endymion. Endymion, a beautiful youth who was the lover of the amorous moon goddess Selene, fathering as many as forty children by her, earned the fate of sleeping forever and thus never aging. His nude, recumbent figure, about to be visited by his lover, is a central image on many pagan sarcophagi, suggesting that death might merely be a blissful sleep.[1] Based on their similar composi-

1. See M. Lawrence, "Three Pagan Themes in Christian Art," in *De Artibus Opuscula*, vol. 40, ed. M. Meiss (New York: New York University Press, 1961), pp. 323-24.

tions, art historians see the Jonah image as a transitional one — a link between traditional Roman iconography and later, more recognizably Christian visual imagery. However, that the representation of Endymion should become the model for a Christian portrayal of Jonah raises some very interesting questions.

But first we need to acknowledge that this image is Jonah and not Endymion, no matter how clearly the iconography of the one is based upon the other. This means that although we should posit some potential reasons for the Endymion prototype, we also should assume that early Christian viewers weren't mistaken about what they saw. Clearly, Jonah, like Endymion, signifies something that Christians hoped for in death — blissful repose. At the same time, assuming that Christians weren't confused about the identity of the figure also assumes that they were familiar with the biblical story and could associate particular illustrations with particular episodes, in a sense providing the captions for each scene. This presupposes a correspondence between image and text, as well as a more inclusive correspondence among the image, the story on which it is based, and the setting or context of the work of art. Although giving the work an approximate date of composition and locating its geographical origins by analyzing its materials, style, or composition takes training and experience, trying to imagine what such a figure might have meant in its context — either to its viewers or to the person who put it there — is another level of investigation altogether. This task moves beyond dating or locating the image, or even noting its stylistic details or the level of artistic skill needed to produce it, and engages the problem of interpretation. In the case of a Christian image, this other task begins by asking theological questions of the artwork — questions that are both speculative and fascinating.

## Art and Textual Interpretation

The title that I gave this chapter, "Visual Exegesis," assumes that visual art can be a means of interpreting stories or texts. "Exegesis" is the term that theologians give to the process of explicating and illuminating texts, especially sacred (biblical) texts. Another word often used to describe this task is "hermeneutics," a term derived from the Greek and referring to the activity of Hermes, the messenger of the gods. Since the gods' messages were

never clear, they needed to be interpreted by someone with special insight — an oracle, for instance. For most of us, visual art seems a lot less intelligible than texts, even though we began our learning with picture books. To comprehend what an artwork means may require some training in observation first, and then interpretation. This involves more than identifying or even translating images into language. We need some special insight, along with some initial information.

Certain external facts supply us with important data we need to begin the interpretative work. For instance, Jonah is seen in these examples on (or in) ancient tombs. This funereal setting is suggestive in itself. Additionally, Jonah's extreme popularity as a subject is also suggestive, indicating that something essential is being expressed by this continually reinforced image. The first of these facts (the burial context) indicates that here we have an image that sends some kind of message about the nature of Christian death or hopes for the afterlife, and the second (its frequency) indicates that the image of Jonah was especially beloved for this purpose. We then must ask how this image speaks to the theme of death and hope, and why this particular image was especially suited to this use.

As we ponder the significance of *this* image in *this* place, we must also consider the story's larger narrative structure, assuming there is some relationship between story and image. Here, however, we see just a part of the Jonah story in the art — only four episodes out of a possible seven. So we will have to decide whether these artistic excerpts refer to the whole narrative or are deliberately focused on certain details. The issue, I think, is whether this is an abridgement, an abbreviation, or merely a citation. The narrative as found in the book of Jonah includes the call of God, Jonah's flight, the tempest, Jonah being swallowed and then spit out again, Jonah preaching to the Ninevites, the Ninevites' repentance, and Jonah's sulking under the gourd vine. Given that this image focuses on the center of the story line only, we may wonder whether ancient viewers were expected to fill in the rest of the plot, to discern a significance related only to the particular moments presented, or to use the image as a pointer to a completely different idea or concept.

The source by itself is not always helpful, in part because the book of Jonah is far from self-interpreting. No paragraph at the end tells us what the story means, or (more importantly) what it *meant* to the third-century Christians who would have commissioned such a painting. We try as much

as we can to set aside our own conclusions about what the Jonah story sig-nifies. Our modern lessons, morals, and metaphors easily mislead us as we try to reconstruct the way a story spoke to an early Christian audience. The only other way to get a perspective on that world, apart from the iconogra-phy, I think, is to refer to other documentary sources, both those that were originally oral (sermons, prayers, and hymns), and those that were origi-nally written (theological and exegetical treatises).

The most familiar form of visual exegesis is book illustration, where text and artwork are put side by side. But illustrated manuscripts were rare in the early church. Most early Christian images were physically separated from the texts to which they referred, and they were not supplied with identifying captions. Accordingly, the relationship that narrative art has to its source (text or story) is, in this context, indirect, and we have to figure out the story the image refers to. In addition, we have to determine whether it was meant to be an illustration at all. For example, a representation of a pilgrim's hat in schoolrooms in Ohio (especially in mid-November) proba-bly calls the narrative of the first Thanksgiving to mind. However, in Massa-chusetts, the home of that first Thanksgiving, most of the time the pilgrim's hat is a sign pointing to the turnpike.

## *Image as Idea: The Relationship between Art and Text*

All this leaves aside the problem of the variant meanings of stories and texts themselves, a topic far too complicated to broach here. But, for the record, let me note just a few hermeneutical problems. The first is the de-gree to which the artwork observed is directly linked to the story (read or performed) or text (written and read) to which it refers. In other words, is this a fairly literal presentation, or does it have a secondary meaning quite apart from the source text? Is the source a "text" in its own right? Is the art-work faithful to the details of the narrative source, or is it free with them? How much does it depart from — or even subvert — the essential story line? Extending this question, we might ask if this *kind* of art can ever be dis-engaged entirely from its narrative source — whether it can ever "speak only for itself" or "on its own terms."

Another potential issue is that both text and art refer to a distinct third idea that serves as a kind of meta-text or common source, to which their

composition and interpretation were oriented somewhat independently of one another. This might be the case with an image that already existed in the culture to which both text and art refer — the Good Shepherd, for example. Jesus was able to use this metaphor because it conveyed a long-standing meaning in Jewish tradition, as exemplified by Psalm 23. However, early Gentile converts identified with another traditional image: the figure of Hermes Criophorus carrying a ram over his shoulders, a symbol of the caretaker of souls, the guide to and through the underworld.

A third issue, of course, is the whole problem of the conflict between intention and reception, between artist and viewer. What one person means and what another one sees are bound to be different, and this variance only increases with time and distance. Modern viewers can't possibly extend themselves into the circumstances of ancient viewers — and in any case, each one of them would have had a different response. Thus we have to allow for considerable divergence and incongruity, for multiplicities of potential meanings and inferences. Texts and images are both extraordinarily flexible. They can be molded to serve different purposes, and if they are lifted out of context, they can be twisted, refocused, or put to yet other uses. In the end, we can offer only partial answers and thoughtful speculation.

Whatever caveats we need to keep in mind, I think that it's obvious from simple observation that the pictorial art of the early church drew heavily on its textual tradition — especially on its sacred stories. However, I also think we need to assume that the stories had already been through a process of interpretation in both oral and written form, and that even these interpretations preceded the use of narrative images in the art of the early church. For this reason, calling this kind of visual imagery "narrative" must involve understanding the word in its broadest sense. Individual images were almost never precise illustrations of specific narratives, and some symbols seem to refer only generally to ideas or values proclaimed in text (e.g., the figure of the lamb or the dove). Other images are no more than shorthand references to a story or ultimately to an *idea* that had become associated with that story. Still, we almost have to rely on the textual sources to interpret the images. Without any knowledge of the texts, we might still find meaning, but it would probably bear no particular relationship to what the ancient viewer perceived in an image. In the Jonah examples, for instance, we see a man being swallowed by a sea mon-

ster and spit out again to lie under a gourd vine. Without knowing the story of Jonah from the Bible, we might attach any or no meaning to it. If we didn't know the story of the Pilgrims' first Thanksgiving, we would make no sense out of an image of a high crowned hat with a buckle (or what it might have to do with a highway). So, when we study ancient narrative art, we have to return to the source text or tradition, at least to give us a starting point. The text is, therefore, our "home base" and functions as a common reference point.

But this in turn raises the complex problem of what constitutes source material. We cannot limit the background material to a few books of sacred scripture or some foundational text; we must also include the vast body of textual interpretation produced by an almost infinitely large body of exegetes, theologians, preachers, poets, hymn writers, and even propagandists from different times and places. The way stories are told, preached, or incorporated into other art forms changes their meaning for subsequent generations. Let's take a familiar example: the magi from the East who come to visit the Christ child. Although the biblical narrative neither numbers nor names the magi, they are invariably presented in the West as three men, usually representing three different races or nations or ages, and often as kings instead of sages or sorcerers. All these details have been added through centuries of textual (and intertextual) interpretation and adapted from subsequent legends.

To reiterate my earlier point: stories and visual images are *multivalent* — that is, they have many possible meanings and interpretations. The artist's intent may differ from the audience's understanding, and among the audience the possible meanings probably number as many as its potential members. The whole matter of the artist's intention and audience reception is almost impossibly complicated and has given rise to whole schools of critical theory, from deconstructionism to linguistic philosophy, from symbol theory to semiotics. All this can be boiled down to a fairly obvious truth, which the ancients knew as well as we modern and postmodern scholars: The perceived meaning of any piece of art depends on the experience, social location, interests, needs, and predisposition of its audience. We can never strip anything down to a single, essential message. Interpretation depends on the circumstances and character of the interpreter.

*Levels of Exegesis: The History of Interpretation*

Positing a multiplicity of meanings is not a particularly modern idea. In fact, the intellectual tradition of the early church presumed different levels of interpretation, especially of sacred texts. These tended to be presented in ascending order of complexity, analogous to the spiritual and intellectual ability of the reader or audience. Adept readers like Origen and Clement of Alexandria (in the third century) and Augustine (in the late fourth to early fifth) could outline three or four levels of biblical interpretation in some detail. According to these theories, there are three types of exegesis corresponding to three levels: first, the literal or historical level; second, the moral and/or typological level; and finally, the allegorical or spiritual level. These three levels corresponded symbolically with the three parts of the person: body, soul, and spirit. The validity of the higher levels did not impinge upon the truth of the lower, since no single interpretation was believed to be adequate. A story — especially a sacred story — would encompass many meanings. A given story was expected to tell many truths at once, to be simultaneously didactic, edifying, and illuminating. What I want to argue is that this theory of levels of interpretation was also applied to the making of visual art in the early Christian era — and in fact, that it still is.

Another common image in Christian tombs was drawn from the story of Abraham's offering of Isaac from the book of Genesis. As early Christian exegetes interpreted it, this text imparted several different messages and could be understood at different "levels." The first, the literal/historical level, viewed the story in a straightforward manner as a factual account of a historical episode. This event "literally" happened in just the way that it was presented. This level can be compared to a news report, and its illustration to a photograph. The event is presented in art in order to provide visual aids and to save the storyteller the trouble of writing long, descriptive prose. It also focuses the drama of the narrative. A picture is worth a thousand words, and may perhaps be able to convey the story to those who can't read for themselves, but it can capture only a moment of that story, perhaps its high point or climax. In this particular case, Abraham is shown standing over his small son, his knife raised in his right hand. Isaac is bound, his hands behind his back. He kneels on the earth next to a small flaming altar. A ram appears on the other side of Abraham. Overhead a hand reaches out

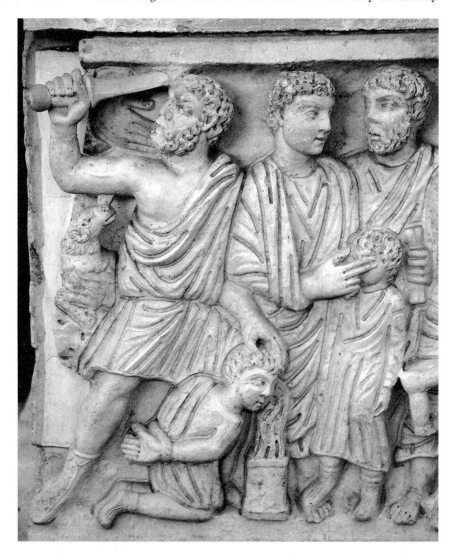

**2.2. Abraham about to sacrifice Isaac, from a fourth-century sarcophagus in the Museo Pio Cristiano, the Vatican**

and down (fig. 2.2 above). We have characters and scene, but their significance would be incomprehensible without the text.

The fact that this kind of approach generally raises questions actually takes us to the next level. Even if one knows the story, the first level gets

caught up in matters of accuracy. A literal-minded viewer will ask why Isaac is shown bound but only next to the altar rather than on top of it — "on top of the wood," as the narrative relates. The story mentions only a voice, not the hand of God (does God have hands?). Such literalism is sometimes associated with children, but it's also typical of adults who have been trained to want their images to correspond closely to the superficial narrative of the text. When the image changes, edits, or expands, the literal correspondence is lost, unless the next level of interpretation opens up the text's meaning as well as the image's meaning.

At this level, the moral level, the general lesson of the story is discovered, rather than just its narrative details. And since more than one lesson is assumed, especially for images in different settings, we must ask why an image appears at all in a particular context, and then why it is either so rare or, on the other hand, so common in this context. In our example, the scene of Abraham about to sacrifice his son appears with relative frequency in catacomb art, while a representation of the episode between Abimelech, Sarah, and Abraham in Genesis 20 is absent. Obviously *this* story contains an important message. It is filled with significance and meaning. It is foundational in a way that another story is not. At the moral level of interpretation, the foundational meaning is also complex. We can find a variety of possible interpretations, especially if we consider the place of the story in the written and oral tradition of the church at about the same time.

Modern commentaries sometimes assert that one of the purposes of the narrative is to demonstrate that God does not expect or desire child sacrifice. At this basic level, this narrative recounts the moment of transition from human to animal sacrifice in ancient Israelite religion. As such, it is an *etiological* myth, one that explains the origins of or reasons for something (like how the fox got its tail, or why there are no snakes in Ireland). At a deeper level, the narrative has often been interpreted as showing what God actually desires from us as sacrificial offering: our faith, our trust, and so on. This is one way of reading the passage in the Epistle to the Hebrews where we are told that "by faith Abraham, when put to the test, offered up Isaac . . . his only son" because he "considered the fact that God is able even to raise someone from the dead" (Heb. 11:17-19).

As an instructive device, the story works differently than a simple didactic lesson. While a direct statement might serve a similar purpose ("God de-

sires our obedience more than our offerings of bulls or incense"), the narrative delivers the message indirectly, and with dramatic and powerful impact. In a similar way, the visual representation of a father about to sacrifice his son makes an intense impression on the mind of the viewer. We have an emotional reaction of horror, fear, or pity, and the vivid (although mental) image stays in our memory differently than a printed text would. This vividness makes the learning experience (the moral lesson) more effective by imprinting our minds with visual and emotional cues. We may call the image back to mind often, unable to describe in precise terms what we learned from it, but each time we revisit it, we experience a fragment of the original emotional response. These experiences reinforce the message of the narrative for us.

But there are still deeper levels of interpretation that we may find in the written tradition, levels that have relevance for understanding the significance of the visual image. Many early Christian homilists and exegetes saw in the story of Abraham and Isaac a foreshadowing of the passion of Christ. Both stories, they pointed out, describe the sacrifice of a "beloved son" who obediently goes to his death. This is often called the "typological" level of interpretation, because it seeks out common "types" or symbols, such as prophecy and fulfillment motifs. The two stories share some remarkable similarities of detail, which to the minds of these interpreters are not at all coincidental. The text from Hebrews cited above already points to the trust of the son and the promise (or possibility) of his resurrection. In other writings, more similarities are highlighted: the three days' journey to Mount Moriah parallels the three days of the Passion, the thicket in which the ram was tangled recalls the crown of thorns, and the ram itself is a symbol of the Lamb of God.[2]

Melito, Bishop of Sardis in Asia Minor in the second century, wrote an example of this kind of interpretation in a sermon in which he elaborated on the significance of the sacrificial Lamb of God in both the Passover and the Passion:

For as a ram he was bound and as a lamb he was shorn,
and as a sheep he was led to slaughter, and as a lamb he was crucified;
and he carried the wood upon his shoulders

---

2. See R. Jensen, "The Offering of Isaac in Jewish and Christian Tradition: Image and Text," *Biblical Interpretation* 2, no. 1 (1994): 85-110.

and he was led up to be slain like Isaac by his Father.
But Christ suffered, whereas Isaac did not suffer;
For he was a model of the Christ who was going to suffer.[3]

Isaac was not slain, and Abraham regained his son. Readers of this story, from the author of Hebrews forward, understood that the relief-filled happy ending prefigures the resurrection of Jesus, where the grieving women who come to prepare the body find an empty tomb instead and "with fear and great joy" run to spread the news. In this way Abraham's test is a foundational moral lesson for both Jewish and Christian tradition, except that in Christian tradition it is reprised (or completed) in the story of Christ's passion and resurrection. The Abrahamic covenant is seen as renewed in this second story of willing sacrifice and divine release.

Early Christian art, like preaching and written exegesis, employed this level of interpretation quite commonly. In fact, the image of Abraham's offering of Isaac actually substituted for a visual presentation of Jesus on the cross in the fourth and fifth centuries. Artistic portrayals of the crucifixion are unknown before the fifth century and are rare until the sixth or seventh century. Often where we might expect to see the crucifixion, we see instead the offering of Isaac. For instance, adjacent to a scene of Pontius Pilate washing his hands is the image of Abraham about to slay Isaac. The juxtaposition's effectiveness relies on viewers to understand the substitution and its message. Illustrated Bibles from the Middles Ages present these types and their counterpart anti-types even more starkly, offering the Old Testament figures as signs of the fulfillment of the covenantal promises through the Gospels.

We can see modern parallels to this use of visual metaphor, when, for instance, the image of the offering of Isaac or the suffering of Christ is used to call viewers' attention to human suffering in general, but especially to victims of injustice or abuse. Consider Marc Chagall's use of the crucifix to describe the suffering of the Jews in Russia, or George Segal's sculpture of Abraham and Isaac, originally designed as a memorial to the anti-war protestors slain at Kent State University. One of the most powerful uses of this ancient story comes through poetry rather than visual art. In the offertory

3. Melito of Sardis, Frag. 9-11, in *Melito of Sardis on Pascha and Fragments*, trans. S. G. Hall (Oxford: Clarendon Press, 1979), pp. 75-77.

section of Benjamin Britten's *War Requiem*, the words of British poet Wilfred Owen, sung by a boys' choir, cause our hearts to sink with their tragic denial of the happy ending:

> So Abram rose, and clave the wood, and went,
> And took the fire with him, and a knife.
> And as they sojourned both of them together,
> Isaac the first-born spake and said, My Father,
> Behold the preparations, fire and iron,
> But where the lamb for this burnt offering?
> Then Abram bound the youth with belt and straps,
> And builded parapets and trenches there,
> And stretched forth the knife to slay his son.
> When lo! an angel called him out of heaven,
> Saying, Lay not thy hand upon the lad,
> Neither do anything to him. Behold,
> A ram, caught in a thicket by its horns;
> Offer the Ram of Pride instead of him.
>
> But the old man would not so, but slew his son,
> And half the seed of Europe, one by one.[4]

The audience must know the story to understand the significance of the image and to grasp its terrible and profound power. Perhaps the audience may also know that Owen himself died in the trenches, just before the armistice that ended World War I. We must then move beyond the narrative itself to find the meaning for our own context.

At the third level — arguably the deepest (or highest) — we encounter the tradition of allegorical interpretation. This level transcends almost all of the text's historical detail and analyzes it entirely as symbolizing the journey of the human spirit toward the divine. At this level, Isaac or Abraham symbolize the obedient soul, undergoing trial and encountering the mercy of God through faithful endurance and transcendence of earthly concerns, finally receiving the divine message or vision. When the image of

---

4. Wilfred Owen, "The Parable of the Old Man and the Young," in Benjamin Britten, *War Requiem* (London: Boosey and Hawkes, 1963).

Abraham and Isaac appears in early Christian tombs, it is this final level of meaning that appears to be intended. Again, the context is crucial to the meaning. I doubt anyone put an image of Abraham and Isaac on a tomb simply to teach visitors a Bible story, although certainly the image worked at the moral level for some patrons or viewers — reminding them to trust and obey God. Nor do I believe that the image was put there only to take the place of a crucifix, unless the observer was expected to understand that a representation of Isaac's willing self-offering referred to the promise of individual salvation granted through the self-sacrifice of God in Christ. Considering the funereal context of the iconography, what the image of Abraham and Isaac most points to is the passage of the human soul through the trial of death, arriving at last — resurrected from the dead and returned to Paradise.

To sum up: stories or texts are understood to bear a variety of meanings, depending on the context and the audience's level of sophistication and spiritual discernment. Visual art that draws from these narratives operates in the same fashion. Sometimes the images are edited, abbreviated, juxtaposed, or transformed to make the point. They aren't usually meant to be faithful or precise representations of the story because they are *already* interpretations of it. This kind of narrative-based image works only when the viewer is familiar with the text or plot. One selected dramatic episode should bring to mind the events before and after, filling out the rest of the narrative.

This is why the best narrative art depends on the viewer's ability to elaborate or project the whole sequence of events from a single scene. The viewer must imaginatively recall, connect, or even create levels of meaning to give significance to the image presented. A picture stimulates a thought, an idea, an emotion, perhaps a whole complex of these, even as it connects to the basic narrative and to a possible series of traditional interpretations. In the fourth century, Gregory of Nyssa vividly described an artwork depicting Abraham about to sacrifice Isaac and expressed his emotions in response to seeing the portrayal:

> I have often seen this tragic event depicted in painting and could not walk by the sight of it without shedding tears, so clearly did art present the story to one's eyes. Isaac, kneeling down, his arms bent over his back, is set before his father next to the very altar; the latter, standing behind

the bend [of Isaac's knee] and drawing with his left hand the lad's hair to-wards himself, stoops over the face that looks piteously up to him as he points the murderous sword grasped in his right hand. Already the edge of the sword touches the body, when a voice sounds unto him from God prohibiting the deed.[5]

An example of the ways a single image can incorporate narrative, moral, typological, and allegorical meanings all at once, and for a particu-lar context, comes from the chancel mosaics in the church of St. Vitale in Ravenna. In a lunette mosaic just above and to the right of the central altar, we see a portrayal of Abraham entertaining his three visitors at the oaks of Mamre (Gen. 18). In the story, the three visitors, pleased by Abraham's hos-pitality, deliver him the promise of a son. To the left in this image, Sarah stands in a small shelter, observing Abraham's hospitality. In the center of the image the three guests, nearly identical, sit down to the table set with three loaves, each marked with a figure of the cross. Just to the right of them we see Abraham about to sacrifice that promised son in obedience to an order from God. Consequently, the mosaic is a visual and time-sequenced narrative composition that tells the story of Abraham, Sarah, and Isaac in two related episodes (fig. 2.3 on p. 42).

While the sacrifice of Isaac served as a visual figure of the crucifixion, the representation of Abraham serving his three guests can be understood as a figure or icon of the Trinity, an interpretation that was promulgated by the early church and later particularly associated with the tradition of Or-thodox icon painting, where this event is presented as three nearly identical male figures seated at a table. In the Orthodox icons, the most famous of which is the fifteenth-century image by Andrey Rublev, the historical narra-tive has been almost omitted. Only a simple architectural element, a tree, re-mains to indicate the geography of the scene, and then only as background. Abraham and Sarah make no appearance. The physical identity of the three suggest the identity of the natures of the three persons of the Trinity, who in this case (as the three visitors at Mamre) are already cognizant of Abraham's faith, Isaac's fate, and the way these events will forecast the future.

5. Gregory of Nyssa, *On the Divinity of the Son and the Holy Spirit*, PG 46.572, trans. C. Mango in *The Art of the Byzantine Empire, 312-1453* (Toronto: University of Toronto Press, 1986), p. 34.

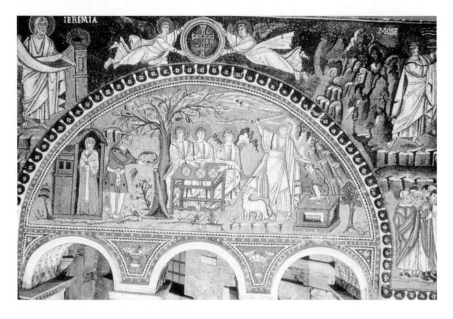

**2.3. Mosaic showing the hospitality of Abraham and the sacrifice of Isaac from the Basilica of St. Vitale, Ravenna**

In the St. Vitale mosaic, we see all of this in one composition. On the right, the beloved son, as a prefiguration of Jesus, willingly suffers and yet escapes death. The three identical figures in the center link the promise with the test, with both images pointing to the covenantal relationship Abraham has with God. If it weren't for the physical context of this image, we might understand it as a narrative or moralizing image only. But the guests' table is set with bread marked with a cross, and as such the image also refers directly to the offering of the Eucharist, which takes place directly below the image at the altar of the church. In order to reinforce this relationship of image, space, and liturgy, the designers of this mosaic composition designed the visitors' table so that it mirrors the church altar. They also placed an image of the offerings of Abel and Melchizedek directly across from the offering of Isaac. All three of these offerings are likely mentioned in the eucharistic prayer offered at the actual altar below. This whole composition, then, emphasizes the connections between ancient hospitality and modern liturgy, the associations of sacrifice and Eucharist, the continuity of promise and covenant, and the parallels between bishop and high priest.

## Jonah: A Case in Point

Let us return, now, to the image of Jonah. At a literal or historical level, the representation of Jonah's story is an illustration corresponding to its source narrative to some extent. Because of its unusual scenic presentation, the iconography actually provides some details about the story to a viewer. The art shows someone being dropped over the side of a boat, being swallowed by a sea monster, being spat out again, and then resting safely on land under a gourd vine. An observer would easily identify a simple plot and label it accordingly: "A man was thrown overboard into the sea, swallowed and then spat out again by a sea monster — and lived."

But this synopsis doesn't really correspond to the biblical story of Jonah, at least as we know it. As a matter of fact, it actually corresponds quite well to an episode in the Disney movie *Pinocchio*. Even though we have four related scenes, much has been left out of the biblical story. As narrative, the art can't stand alone; the viewer has to fill in almost all the salient plot details. Even assuming, however, that a viewer is familiar with the text and can supply the rest of the story, we must still admit that the pictorial composition is deliberately (and consistently) selective. The imagery omits Jonah's fleeing God's call to go to Nineveh, which is the whole reason he got on that storm-tossed boat in the first place (scene 1). It also omits Jonah's successful preaching, which was why he was sulking under the gourd vine (scene 4). The tradition has selected those scenes it deemed most important to bear the weight of the story's meaning and significance.

So while we can conclude that these images are references to a story that most viewers know fairly well, we also see that they guide a particular "reading" of the story's purpose or point. One possible reading is that Jonah is punished for his rebellion, learns his lesson, promises to obey God, and is rescued. This moral interpretation would be quite appropriate if we were seeing this as Christian education or a visual aid for a moralizing exhortation from the pulpit on a Sunday morning. But these images don't appear on the walls of a church or the classroom for catechumens; they appear on the walls of a tomb, near the Good Shepherd, and are surrounded by lovely images of birds and garlands of flowers.

Presuming this placement is significant and not merely accidental leads us to the next level of interpretation — the symbolic or figurative. Jonah was dead and was brought back to life. The art certainly emphasizes

these moments in the narrative, especially if Jonah's prayer from the stomach of the fish is interpreted as a plea for resurrection from death rather than for a second chance to go to Nineveh: "Out of the belly of Sheol I cried, and you heard my voice. . . . I went down to the land whose bars closed upon me forever; yet you brought up my life from the Pit. . . . Deliverance belongs to the Lord!" (Jon. 2:2-10). That would mean that the vomited Jonah is being released into Paradise, not returned to his dodged responsibilities, and the reclining Jonah is already in heaven, not just sulking in a garden. Art and text, or at least the memory of the text, or even the memory of an exegete's *interpretation* of the text, is essential to the meaning.

Two aspects of the art that have nothing to do with the Scripture text underscore this interpretation. First, Jonah is naked going in and out of the mouth of the fish, and naked again when he reclines beneath the vine. Second, his bodily posture under that vine is the exact position of Endymion, enjoying an eternal repose. Since, according to Christian teaching and practice, death and resurrection into Paradise are achieved through the waters of baptism, the imagery can be interpreted as a reference to that rite of initiation. The rolling waves around Jonah's boat where the sea creature is swimming can be read as an allusion to the water in the font, while Jonah's nudity refers to the nakedness of third-century candidates for baptism. The iconography sends a message: the soul of the dead is blissfully resting in heaven because the promise of baptism has been realized (fig. 2.4 on p. 45).

This death and resurrection symbolism is validated but also extended to become a Christological figure through Jesus' own interpretation of the "sign of Jonah" as reported in the Gospels. In Matthew 12:38-41 (with a parallel in Luke 11:29-32), Jesus says, "For just as Jonah was three days and three nights in the belly of the sea monster, so for three days and three nights the Son of Man will be in the heart of the earth." In this text Jonah is regarded as a "type" of Christ in the same sense that Isaac was. However, Jesus adds something to the typology by contrasting the repentant Ninevites with "this generation" who don't see that "something greater than Jonah is here" (v. 41). The omission of the Ninevites from the catacomb iconography (a case of text and image divergence) only strengthens the argument for the pre-eminence of the death/resurrection interpretation.

Another text in the New Testament might help to pull all the threads of this somewhat divergent tradition together. In his epistle to the church in Rome, the Apostle Paul makes the comparison between Jesus' death and res-

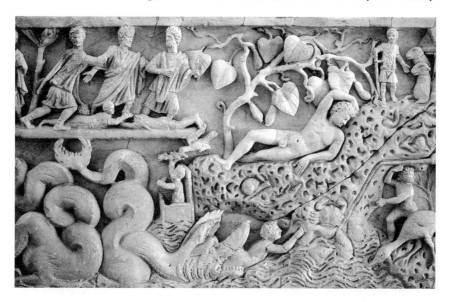

**2.4. Jonah as carved on an early Christian sarcophagus, now in the Museo Pio Cristiano, the Vatican**

urrection and the Christian's — through baptism: "Therefore we have been buried with him by baptism into death, so that, just as Christ was raised from the dead by the glory of the Father, so we too might walk in newness of life" (Rom. 6:4). By the association of these different ideas in a sort of mathematical equation (Jonah = Christ's death and resurrection = baptism of the believer), we arrive at an almost obvious conclusion. The image of Jonah symbolically refers to Christ's death and resurrection, in which the Christian participates through baptism. Baptism is the believer's guarantee of resurrection from death and rebirth into Paradise, which is iconographically symbolized by Jonah's deliverance from the sea monster. In this sense the deceased person in the tomb is also a "Jonah." The image thus speaks at many levels.

### The Congruence of Textual and Visual Interpretation

These two examples of Jonah and Abraham and Isaac argue for the congruence of textual and visual interpretation. This apparent harmony makes some scholars uneasy, however. By focusing on the congruence, they ar-

gue, we make the relationship of text and image a little too interdependent, overlooking the ways in which text and image differ from one another, or the fact that they address different audiences, or that they employ different modes of discourse. The temptation is to view artworks as understandable primarily through recourse to texts. This, in turn, allows some confessionally biased interpreters to select and manipulate both texts and art to produce an overly neat correspondence between authorized theology and visual imagery. Scholarly objectivity is forfeited in favor of apologetic or dogmatic aims. When historians see what they want to see or use the evidence of visual images to validate or demonstrate particular theologies (or even ideologies), they have misused them. A long-standard practice on the part of some of reading mainstream theology into ancient iconography has led other art historians to reject the exegetical tradition of the church as an aid to interpretation.[6]

But images never stand alone or apart from culture — and culture includes stories, texts, and contemporary interpretation of those stories and texts in verbal as well as visual modes. We must be equally aware of the dangers of reading into, misreading, and overlooking. In his book *The Clash of Gods,* Thomas Mathews makes the point eloquently:

> Images are not neutral; they are not just stories put into picture. Nor are they mere documents in the history of fashion. Images are dangerous. Images, no matter how discreetly chosen, come freighted with conscious or subliminal memories; no matter how limited their projected use, they burn indelible outlines into the mind. Often images overwhelm the ideas they are supposed to be carrying, or dress up with respectability ideas that in themselves are too shoddy to carry intellectual weight. Images not only express convictions, they alter feelings and end up justifying convictions. Eventually, of course, they invite worship. One cannot write history without dealing with the history of images.[7]

This assertion — that the study of images is critical to an understanding of history — can logically be extended to a study of theology. Images

6. See Thomas Mathews, *The Clash of Gods: A Reinterpretation of Early Christian Art* (Princeton: Princeton University Press, 1993), pp. 3-22.

7. Mathews, *The Clash of Gods,* p. 11.

are vehicles for theology, both at the popular and the official level, both within the institution of the church and outside it, as supports or subversions of mainstream teachings. Images as symbols are filled with unarticulated meaning, in the liturgy as well as in the daily practices of the faith. Images as ideas are complex, adaptable, and multivalent. They do not mean only one thing. They encompass the depth and richness of meaning attached to any idea or symbol.

As we begin to incorporate the study of visual art into the study of history or theology, we will have to decide whether the social groups that have provided us these two kinds of evidence are the same, quite distinct groups, or separate but overlapping communities. In other words, are the writers of those theological treatises also viewers or users of images? This question takes us into treacherous and still uncharted terrain. We have to posit and examine distinctions between authorized (official) and unauthorized religious practices, between private and personal and public and communal, or between the elite and the rank and file. We will need to ask whether images appear different to literate viewers than to non-reading viewers in a particular culture, whether the gender, social class, or status of the viewer changes the way an image is perceived, whether visual art (in general) is any more available to all members of community than texts. We will need to ask whether observational skills are any less instilled through education than the skills associated with verbal analysis.

At the core of all this uncertainty lies the question of whether images and words are different or similar things. The technical meaning of the term "iconography" is, of course, "writing with pictures," which might strike some of us as a one-word oxymoron. We might ask whether the making of pictures can be described as or equated with writing, or whether the two modes of communication are essentially compatible or even similar. Do we reduce the power of art if we speak of it as a kind of "visible language"? Of course, to speak of art at all requires that we use language, however inadequate or fundamentally flawed it might be. Perhaps we need to speak only of different kinds of signs or symbolic modes.

Before we declare ourselves helpless to resolve this conflict, I propose that we pause and remember that language itself is essentially the formation of mental pictures — pictures constructed of signs or symbols in the form of words. Words are like the colors and the shape, the objects and spatial relationships, the patterns, line, texture, and scale of a visual composi-

tion. As individual signs, they are no more precise than images; they only exist in any meaningful way in a particular context, and only by being interpreted by individual readers or listeners — all of whom bring their own particular situations, biases, and individual personalities to the task of making meaning out of what they see, hear, read, and even *think*. And so it is with art. Every culture has its own visual "language" with its visual grammar and vocabulary, structure and syntax. Even non-figurative art has such a visual language, which can be as intimidating and mysterious to the untrained eye as a foreign language may be to the untrained ear.

But something may exist beyond the individual, something that approaches a more universal, less relative meaning. Some call this revelation and assert that it has divine origins. Christians, for example, make the claim that their sacred texts — scriptures — contain the revealed Word of God. How terms like "contain" and "revealed" and (especially) "Word" should be understood is a matter of dispute. Nevertheless, Christians believe in the existence of some kind of eternal and transcendent truth, even when, so far as they can tell, they get only occasional and fleeting glimpses of it. I would argue that such glimpses come as often through the experience of looking at art as through the reading or hearing of a story or a sermon or a Sunday school lesson, which are all art forms that bring the "Word" to life for the attentive audience. For some people, moreover, the image leaves a more lasting memory and comes back to mind more sharply than a message in ordinary prose.

Perhaps we should say that the word and the image are like siblings — siblings who share their essence or origin, and who are so connected that separation would impair them both. Such dependency doesn't mean that they are always compatible or even congenial. Siblings clash, contradict, and see from different vantage points as much as they support and reinforce one another. They play different roles in the family, and yet they emerge from the same womb and receive nurture from and work to sustain the life of the family unit. One without the other would be diminished. Words can never adequately describe what we see and know through that process of seeing, nor can images be completely detached from ideas or language or — most of all — stories. They both lead to a fuller, richer apprehension of an idea.

By way of final illustration, let us consider another common tomb motif from early Christian art: the depiction of Noah. Noah is presented in a

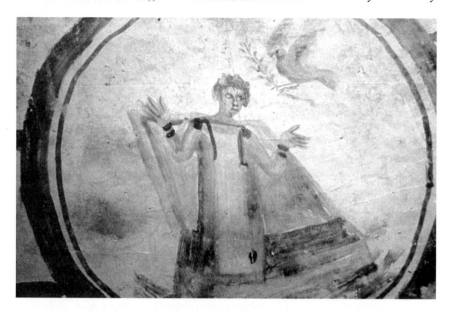

**2.5. Noah as depicted in the Catacomb of Peter and Marcellinus, Rome**
International Catacomb Society, Estelle Brettman, photographer

peculiar way, or so we might think, since many of us are used to seeing Noah in an American folk-art style with Mrs. Noah and all the animals. This Noah looks more like a child's jack-in-the-box than a righteous man who walked with God (fig. 2.5). Still, we can identify him by means of the dove with the olive branch and the water on which he floats. The episode is carefully selected (the end of the Flood), and the image is highly abbreviated. Its context — funereal again — is an important aspect of its significance. Noah, of course, is rescued from death because of his righteousness, so we could interpret this image as a kind of prayer in which the dead soul asks God to recognize his or her righteousness and act accordingly. This is the sense in which the story is interpreted in the New Testament, in the Epistle of Second Peter — that God's rescue of Noah is an indication of a promise "to rescue the godly from trial" (2 Pet. 2:4-9).

There might be an additional message intended here — one that isn't so rooted in the historical sense but that also comes from the New Testament, this time from the Epistle of First Peter, where we are told that Noah's salvation was a prefiguration of Christian baptism (1 Pet. 3:20). Note that neither the first nor the second interpretation requires any more than an al-

lusion to the narrative, which is what we get from the funereal composition. Dove and water are significant to both of the meanings: in the one case, the dove brings the news of nearby land (and thus rescue from the water), while in the other, the dove and the water refer to the rite of baptism — first the water bath and then the gift of the Holy Spirit. To understand the image, we have to know the story *and* its moral lesson, and to understand its significance as a sacramental symbol, we have to know how certain details were echoed in the liturgy.

In this way, the early Christians created a "composite" form of communication that was equally dependent on text (word) and picture (image). Neither is understandable or complete without the other, and their joint relationship bears responsibility for making meaning and passing along that meaning to future generations. Pictures require as much attention, acumen, and appreciation as texts and are no less complicated, sophisticated, or intellectually challenging. If anything, they concentrate or even compress a number of related but successively more abstract ideas into one symbol or image. At the same time, our comprehension of any or all of those possible meanings depends on our familiarity with the story as well as the way that story was given meaning by a particular community at a particular time.

In conclusion, we should have no doubt that visual images are an effective mode of interpreting sacred stories, so long as they retain some level of dialogue with the source narrative. Once the narrative is lost or forgotten or the connection with it is utterly obscured, the image either ceases to have its intended meaning or finds itself signifying something else entirely. For example, once children no longer know the story of the first Thanksgiving, the Pilgrim's hat will signify *only* the entrance to a highway, although no one will understand why. The point is that the meaning in pictures depends on the interactivity with the stories and the familiar interpretations of those stories as known to the observers. This will in turn be affected by the particular context of the image (e.g., the walls of a tomb, the pages of a manuscript, the windows of a cathedral), and then finally by the imagination and insight of the viewers themselves.

# 3 Idol or Icon? The Invisible and the Incarnate God

One of the things I often ask of an academic class on worship and the arts is to come with me to a Greek Orthodox church, where we attend a service and then have an opportunity to speak with the local priest and ask some questions. As we arrive, I observe my students' reactions as they watch members of the congregation enter and greet the small painted images in the narthex or the sanctuary, lighting candles in front of them, bowing before them, even kissing the paintings themselves. During the service, congregants sometimes get up and move to one of the holy pictures, light a candle, and offer a prayer, as if having a private devotional moment in the midst of the larger congregational one. Many of my students have never seen anything like this, and I sense their bewilderment, curiosity, discomfort, sometimes even anxiety. Some of them are moved by this demonstration of piety. Others are alarmed and judgmental, upset by what seems to them to be idol worship, worried that they might even be implicated in some way in a sinful act. For most of them, this is a cross-cultural experience. They have encountered a mysterious world of symbols and gestures, priests in elaborate vestments, flickering candles, and wafting incense where a cantor chants in an ancient and unfamiliar language.

The New England free-church environment, in which most of my students worship, by and large prides itself on its simplicity and clarity, whether the style is formal or informal. The traditional church building is well-lit and airy, the walls bare, and the decoration minimal. People arriving for Sunday-morning services are politely greeted by an usher and given a bulletin. They find a seat, usually in a pew, where they sit and wait quietly for the service to start. Everyone faces the main liturgical "action," which

normally takes place in the front of the church. Members of the congregation rarely get up and move to a different place in the room, unless they are carrying out a noisy baby. The worship — in English — is stately, straightforward, and understated in manner. The intellectual and verbal modes of communication are emphasized. Scripture passages are read, prayers are spoken in unison, hymns are sung with gusto, and preaching is a high point. The clergy are dressed simply and somewhat somberly, whether they are robed or in street clothes.

In these churches, Communion or services of the Lord's Table are usually infrequent (once a month is the norm), and clergy and laity perform their tasks with solemn dignity, distributing the elements and repeating the ancient prayers without added sounds, fragrances, or gestures. People receive bread and grape juice in the pews, quietly passing the plate and cups from one to the next with minimal fuss. In the traditions of most of these churches, the elements are neither objects for devotion nor mediators of divine presence to communicants. They are, rather, symbols of a historical meal, meant to join the partakers in remembering that event and sharing the meal together. If one of the primary aims of the Orthodox is to invoke the presence and mediate the holy through the image and work of the eye (fig. 3.1 on p. 53), a principal aim of Reformed worship is to educate the mind and elevate the spirit through the word and work of the ear.

So my students are understandably and powerfully affected by the Orthodox experience. I particularly remember one student, a Baptist woman in her late fifties, who telegraphed her anxiety through facial expressions and body language throughout the Orthodox service. When, at the end, the priest reappeared and offered to answer any questions our group had, she reluctantly but courageously piped up: "I was wondering about the incense. Your assistant was swinging it all around the front of the platform at the beginning of the service." "Yes," said Father Nick, explaining that the deacon was thereby offering honor to the holy images. "We believe the icons invite the presence of the saints they depict, and so we fill the air around them with the sweet smell of the incense." Then my student noted that the deacon had also censed the altar table behind the icon screen. "Yes, we also honor the elements of the Eucharist — the bread and wine. They too are images of God." And also, she said, "you swung that censer over the people in the pews, over me." "Yes, because you too are an image of God." When, several years later, this woman returned to campus, she sought me out to tell me that this ex-

**3.1.** Iconostasis in the Holy Trinity Greek Orthodox Church, Nashville, Tennessee

change was an important moment in her seminary education. This was the moment when she was reminded of a good Baptist principle — that she too was an image of God — from a Greek Orthodox priest.

Most of my students believe that praying to statues or pictures is a form of idolatry. Although they are accustomed to images in stained-glass windows (in other Protestant churches, if not their own), these images usually show biblical scenes and are accompanied with words that identify the sto-

ries they portray. While these attractive images might enhance an atmosphere of worship, no one offers a prayer in their direction. They are decorative — sometimes even beautiful — environmental enhancements that teach religious lessons. Now and then someone might ask whether such decoration is distracting or theologically misguided in churches that pride themselves on their "Puritan heritage," but, for the most part, such decoration is at least tolerated by congregants because it serves a didactic rather than a devotional function.

This raises the question of what we might define as an "idol." Some years ago, I learned firsthand how differently people from different traditions understand this term. I visited a Catholic university to present a lecture on the history of visual images of God to a group of art and art-history students, mostly undergraduates. I spoke at some length about different religious attitudes toward the dangers of images of the divine, citing standard theological arguments about the possibility or impossibility of visually representing God. When I finished, I asked whether there were questions or points the students wanted to discuss. The awkward silence told me that I had either offended or baffled my audience. Finally an explanation, framed as a question, informed me that to many of those listening, the word "idol" referred to a statue or god from *someone else's* religion, and therefore it made no sense to ask whether "our" images of Jesus, Mary, and the saints could in any way be called "idols." My use of the term "idol" definitely implied a polemical point of view, one that I had, unfortunately, taken for granted. The questions that never failed to be asked by my Protestant students had not occurred in the same way to these Catholics I now addressed. They had expected a different sort of lecture, perhaps one that illuminated and analyzed the long history of Christian artistic representations of the divine. Whereas my starting point had been the question of whether one could produce images of the divine *at all,* they took the art for granted and were eager to know more about its historical and cultural variations as well as theological implications.

The problem of distinguishing between acceptable religious images and unacceptable "pagan idols" is not new. Nor is my discovery that misunderstandings often arise at the level of practice as well as theory — not just how we think about holy images but what we do with and about them. We are, of course, at one stop along a long history of theological debate, conciliar decrees, political prohibitions, vandalism, and even destruction.

Religious bodies want to know and to do what is right in regard to visual images; few feel indifferent about the question of idolatry and the place of figurative art in worship. On the one side are Christians who see all religious images as potential idols and believe that their use will call down divine wrath. On the other side are those who cannot imagine worship without the visual dimension and who argue that the denial of images is tantamount to the denial of Christ's incarnation, the mediation of saints, and the goodness of creation. The conflict between these different points of view has led to schism and even violence at different points in history and given us a legacy of hurt, fear, and misunderstanding between artists and theologians.

## Iconoclasm in History

Possibly the most infamous and destructive chapter of this conflict began in the middle of the eighth century. From around 725 to 842 C.E., the Byzantine Empire underwent a theological and political crisis initiated by a violent conflict over the place of visual art in the church — whether the devotional use and veneration of images of the saints was compatible with Christian teaching and tradition, or whether such behavior amounted to an idolatrous heresy. The two distinct positions on the matter (those who would destroy images — the iconoclasts — and those who venerated them — the iconodules) were led from the very top of the imperial structure: the emperor or empress currently in power. At the inception of the controversy, the first iconoclastic emperor, Leo III (717-741), ordered the destruction of all images used for devotional purposes in churches and in homes, including mosaics, painted wood panels, frescoes, and relief sculpture. Those who defied the order were persecuted. Leo's son, Constantine V (741-775), continued his policy and added an ecclesial dimension by calling a church council on image worship and penning some of the doctrinal arguments himself.

The essential argument of the iconoclasts was that the icons were fraudulently claiming to present something they could not possess: the image of the divine or the holy. Paint and stone and wood were incapable of revealing anything more than the materials and arrangement of colors used to make a likeness; they could not be in any sense animate, for they

were made of inanimate ("dumb") matter. Moreover, the Law given to Moses on Sinai forbade any kind of graven image: "You shall not make for yourself an idol, whether in the form of anything that is in heaven above, or that is on the earth beneath, or that is in the water under the earth. You shall not bow down to them or worship them" (Exod. 20:4-5).

Although the conflict was theological, it was not limited to the world of the church, since it had significant political and social ramifications. Almost every aspect of Byzantine daily life was affected by what amounted to a civil "culture war" over the nature of devotional art. Religious images were in homes, schools, hospitals, and workplaces. Saints portrayed in them were the patrons of institutions and individuals, and had been for centuries. They were credited with miracles manifested through particular images. Those whose devotional lives incorporated the use and presence of these images could not imagine their absence or countenance their destruction. For them, smashing an image was an act of sacrilege and desecration.

From the perspective of the other side, those who venerated the images — or, worse yet, made them — were blasphemers. They had mistaken vain images for the holy prototypes they portrayed. By hallowing mere representations, icon painters attempted to circumscribe the divine nature, as if they could present the invisible in paint or stone. Indeed, the Iconcoclastic Council of 754 issued this stinging statement: "How senseless is the notion of the painter who from sordid love of gain pursues the unattainable, namely to fashion with his impure hands things that are believed by the heart and confessed by the mouth!"[1] Such a charge, not only of vanity but also of sacrilege, was particularly aimed at images of Christ, whose invisible divine nature could no more be depicted than the transcendent and unseen image of God.

The iconoclasts did not perceive art per se as the problem. They tolerated secular art that avoided religious content or invited prayer. But in their view, representations of holy persons invited superstitious and idolatrous behavior. If the images were merely decorative or didactic (giving glory to God, teaching Scripture lessons, or reminding viewers of the virtues of the saints), they might be permitted. But the use of icons overstepped those boundaries and encroached on the sacred terrain of the holy. The icons

---

1. From the definition of the Iconoclastic Council of 754, in Cyril Mango, *The Art of the Byzantine Empire*, 312-1453 (Toronto: Toronto University Press, 1986), p. 166.

were being confused with things holy in themselves, as if they were to be placed among those material things (e.g., the elements of the Eucharist) that were consecrated and set apart as mediating the invisible, divine essence to the faithful.

Modern historians have debated — in almost endless books and articles — the sources of and reasons for Byzantine iconoclasm. According to one, certain groups of charismatic monks or local holy men (who were the producers and champions of the icons) threatened the centralized religious authority of the official church (and its patriarch in Constantinople) as well as the centralized political authority of the emperor (also in Constantinople). Another pointed to the possible threat or influence of Islam (an aniconic religion), while still another argued that since Leo and his family came from the eastern part of the Empire, they were outsiders in Constantinople — and offended (or utterly bewildered) by its rich culture and elaborate liturgy. Attentive to gender issues, yet another historian speculated that this was a battle of the sexes — a struggle between the "abstract masculine" and the "embodied feminine" principles represented by the warring emperor and empress.[2] Note that almost all of these theories presume that *iconoclasm* needs to be explained — and not the use of icons. This may be the case because, since the end of the controversy in the ninth century, the Eastern Church has incorporated icons into its worship and theology. At least for that part of the Christian church, it seems mainstream.

From the beginning of the conflict to its end, the pro-icon faction was as sure as the iconoclastic faction that it was on solid theological ground. At first, the defenders of icons — iconodules — justified the images by claiming that icons were holy in the same way as the "sacred and life-giving cross." Over time, their defense flowered into a full-blown theology of the image. This theology depended on the Orthodox dogmas of creation and Christology as set out in the fifth century and elaborated through the subsequent three hundred years. Essentially they argued that created nature was not alien to the divine essence. This had been affirmed in the Incarnation of Christ — God in human flesh — an event that united two opposite natures (created and uncreated) in one person.

2. For a general discussion and a solid bibliography, see *Iconoclasm: Papers Given at the Ninth Spring Symposium of Byzantine Studies, University of Birmingham, March 1975*, ed. A. Bryer and J. Herrin (Birmingham, U.K.: University of Birmingham, 1977).

According to the iconodules, both objects from the natural world *and* human-made images are capable of revealing the invisible divine — even if in an incomplete and mediated fashion. As Paul had insisted in his letter to the Romans, the eternal power and divine nature of God are reflected in the things God has made (Rom. 1:19-20). In the sme way the icon shows forth the invisible through the visible object and even invites its presence.

John of Damascus wrote three apologies for holy images in the early eighth century, about the time the iconoclasts were gaining the upper hand. His writing has been viewed as definitive for the pro-image side. In his first defense of holy images, John says, "I am emboldened to depict the invisible God, not as invisible, but as he become visible for our sake, by participation in flesh and blood."[3] He continues his argument by asserting that Christ's birth from the Virgin, his baptism, transfiguration, miracles, death, and even resurrection were all seen by ordinary eyewitnesses and were attested to. The saints, too, can be portrayed, because their external appearance was visible to others and even projected a measure of their holiness, which, although invisible in essence, could be apprehended by virtue of its attachment to material form.

John further argues that a different kind of worship is offered to images than to their prototypes. The icons of holy persons are given a kind of relative veneration, not the "absolute worship" reserved for God alone. However, since the holy image both draws from and presents the reality of the model, the painting or likeness has a particular kind of role or function far beyond its mundane elements of wood or paint and more than usually claimed for an ordinary religious picture. The icon is a vehicle for an encounter with the holy. This is why Eastern theologians often speak of the image as a gate or a channel that connects earth to heaven. By venerating images, one offers worship not to physical objects but rather to the one who is portrayed through the medium of the paint or wood. The honor given to the image is thus transferred to its prototype.

The initial ascendancy of the iconoclastic position had a long-term impact on the production and use of religious art in general, especially on portraits of the saints, the Mother of God, and Christ. A large portion of the religious art made prior to the eighth century was lost at that time —

---

3. *John of Damascus: Three Treatises on the Divine Images,* trans. Andrew Louth (Crestwood, N.Y.: St. Vladimir's Seminary Press, 2003), Treatise 1.4, p. 22.

smashed, defaced, burned, or buried in the name of piety and obedience to God. Exactly how long this position dominated is unclear (from about 726 to 780 and again from 814 to 842), but when the conflict finally ended, the defenders of icons were victorious. The icons were once again installed in churches, and theologians outlined the authoritative teaching on the place of imagery in Christian theology and practice. The victory of the icons is still celebrated in the Eastern Church as the Feast of Orthodoxy, which falls on the first Sunday in Lent.

Although it's not easy to disentangle the various motives that provoked the iconoclastic controversy in the eighth century, both sides, iconoclast and iconodule, claimed that they were following the teachings and practices of the early church — if possible, all the way back to Jesus and the apostles. Since Orthodox Christians aim to recover and even replicate the practices and teachings of the apostolic church, scholars and canonists prepared *florilegia* (compendia of texts and testimonies from ancient authorities), which demonstrated the validity of their arguments by appeal to precedent or antiquity as much as to Scripture. Neither side ultimately marshaled sufficient and irrefutable evidence to claim either rejection or acceptance of visual art in the early church. And even while they did agree that Christians have always condemned idolatry, they did not agree on what constituted it.

### The Protestant Reformation in the West

The Protestant Reformers in the sixteenth and seventeenth (and again in the nineteenth) centuries also appealed to tradition and ancient practice, although in a very different way from the Byzantine or Orthodox churches. They focused specifically on the question of the value or role for visual images, and often with less theological subtlety. Generally, a Reformational point of view held that the only true and holy image and source of revelation was contained in Scripture — the Word, read, heard, and preached. In contrast to John of Damascus (and his followers), Protestant theologians usually claimed that *no* image could be equal to the biblical text. The purest worship was with the heart, head, and mouth, not with the eye. Adornments in the church were, at best, aids to the memory or illustrations for non-readers. At worst they were distracting and possibly dangerous traps

that heretically confused the creation with the Creator. For many pious Christians, the invisible God's primary and perhaps only reliable mode of self-revelation was Holy Scripture.

Of course, for the most part the Protestant Reformers of the sixteenth and seventeenth centuries were objecting to contemporary popular religious practices in the West, and not debating the highly developed theology of the icon in the East. Unlike the Byzantine iconodules, medieval Western Catholics lacked a systematic theology of images, and, apart from selected efforts to control certain innovations, artwork was not overseen by church authorities to the same degree. Even though churches, homes, and tombs had been decorated with painting, sculpture, mosaics, and other forms of visual art from at least the third century onward, they were not understood as essential to the knowledge of or worship offered to God. In fact, many medieval bishops worried about the possibility that images might be used idolatrously. Meanwhile, representations of the saints or the life of Christ were important devotional aids for medieval worshippers. They focused prayer and offered edifying and inspiring reminders to live a pious and virtuous life. But, even though they were meant to evoke a certain response of awe from their viewers, they were not precisely vehicles for reflecting — much less mediating — the Holy One's presence.

The art of late medieval Christianity, like its architecture, evoked awe and inspired piety. Viewers were affected by the images of saints' suffering and exhorted by scenes of courage and fortitude. Above all, representations of Christ's Passion were meant to produce profound emotional and even physical responses of sympathy and adoration. At the same time, the art also supported and reflected a transcendent theology. God and heaven were majestic and beautiful. Despite these functions, human-made works of art were not placed on the same plane with the consecrated host or the relic of a saint, even though worshippers might kiss the feet of Christ's body on the crucifix, light candles in front of it, crown it with flowers, or process it through town on a feast day. In fact, the response of the Western church to the Byzantine iconoclastic controversy (as demonstrated in the *Libri Carolini*, a treatise penned by a theologian in Charlemagne's court) tended to criticize both iconoclasts and iconodules, arguing generally for a proper distinction between image and relic, and arguing specifically that saints' physical remains were more holy than their portraits could possibly be.

Although the Protestant Reformers may have been aware of the theol-

ogy of the icon in Eastern Christendom, it was the very different art of the medieval Western church that drew their ire. By elevating the word over the image, they emphasized the immateriality and invisibility of the divine essence, and they insisted that true worship should focus on the invisible and textual rather than the visible and sensible. The beautiful things of nature, while not in any sense evil, could mislead the one who paid them too much attention, thus blurring the distinction between Creator and creation. Human-made objects likewise were snares, fooling and distracting the mind and shifting its focus from higher things to those that are base and worthless. They also had no value in aiding either maker's or donor's salvation. Many centuries earlier, Augustine, worried that material beauty might distract from true worship or knowledge of God, had concluded that the pleasure of art (in his case, particularly music) could encourage piety but also be the object of misplaced worth: "My physical delight, which has to be checked from enervating the mind, often deceives me when the perception of the senses is unaccompanied by reason."[4]

Following Augustine's warning, Protestant Reformers emphasized the importance of the words over the melodies in their hymns (sometimes banishing music altogether), were circumspect about the value of pictorial art, and were cautious about worldly and physical delights. The biblical text that seemed germane to this emphasis insisted that God is "spirit" and that those who worship God must do so in "spirit and truth" (John 4:23-24). Such spiritual worship was understood as the opposite of bodily worship because it engaged the rational or intellectual faculty rather than the senses. Thus the abstract word became elevated over the concrete image in certain Christian theologies, especially those that stressed God's transcendence of humanity and the ultimate unknowability of the Divine One. A familiar nineteenth-century hymn by Walter Smith echoes a line from First Timothy: "Immortal, invisible, God only wise/In light inaccessible, hid from our eyes" (1 Tim. 1:17).

Thus, from the sixteenth century on, a variety of Protestant theologians cited the Second Commandment to argue that figurative art in the church was tantamount to idolatry, whether or not images were treated as anything other than merely decorative. Because of their emphasis on a

---

4. Augustine, *Confessions* 10.33.49-50, in *Saint Augustine: Confessions*, trans. H. Chadwick (Oxford: Oxford University Press, 1991), pp. 207-8.

purely anti-materialistic understanding of worship (and sacraments), most of these groups perceived images as stumbling blocks to worshippers. For these reformers, the opulence of the church's art was at best an external distraction and at worst an inducement to superstitious or magical behaviors. The physical or artistic image was seen as drawing the mind to this world rather than lifting it up to the transcendent world of the divine, tempting deluded worshippers to confuse what was base, material, and temporal with the true, spiritual, and eternal. Christianity, like Judaism, was a religion "of the book." God was never silent, but God was always invisible.

Despite certain general trajectories, however, the early Protestant attack on images cannot be easily characterized, since it shows a wide spectrum of positions from place to place and from person to person. Political situations varied considerably, and those who joined the iconoclastic movement included clergy and laypersons as well as representatives from all social classes. Certain cities and regions experienced an extreme or thoroughgoing iconoclasm that took place over a longer period of time and had lasting impact. Other attacks were short and sporadic, even quickly aborted. Whereas Andreas Karlstadt and Huldrych Zwingli and their followers pressed for the removal of all art forms from the liturgy and all visual images from the churches, other reformers took a more conservative and gradual approach. Views on what constituted an idolatrous image also varied. Visual art might be allowed in purely secular or even domestic settings, and (depending on the group) certain images might even be tolerated in a religious context, including representations of Christ's Passion. On the other hand, some reformers extended their attack to art objects beyond representational art, including eucharistic vessels, vestments, and candlesticks.

Certain moderate voices urged restraint and leadership by example. The word-oriented worship in Calvin's Geneva, for instance, set the tone for its simplicity in music and its plainness of setting, but Calvin and his followers were not radically against art, so long as it was limited to a didactic representation of historical/biblical events and stories or reinforcement of Christian morals. By the time Calvin assumed his position in Geneva, however, the city and its churches were already "purified," and consequently he firmly believed that the Word (including Scripture and preaching) was God's primary medium of revelation from the beginning. Calvin plainly as-

serted that the making of images was always a temptation to idolatry and a mark of decline. However, art that claimed no devotional function might be tolerated for the edification of the weaker members of the community. He could claim, "I am not gripped by the superstition of thinking absolutely no images are permissible. But because sculpture and painting are gifts of God, I seek a pure and legitimate use of each."[5] His followers in succeeding generations would thus embrace a variety of limited but authorized ways to incorporate the arts in Christian worship.

On the other end of an iconoclastic spectrum, Luther and most of his successors tended to be more tolerant of the arts so long as they were not viewed as works of righteousness, and were properly understood as a means of "glorifying God through worship." Luther focused more of his ire on Karlstadt's "wanton violence and impetuosity," claiming that he too wanted images removed but that the removal should be done without unnecessary uproar. Luther further claimed that the Law of Moses forbade only images of God that might be worshipped, and that a crucifix and other holy images were "adiaphora" (not forbidden by Scripture). In the well-known conclusion to his polemical treatise against this particular opponent, he came close to arguing that the visual arts were a means of grace — akin to the preached word — so long as the images were not set up in God's place:

> Of this I am certain, that God desires to have his works heard and read, especially the passion of our Lord. But it is impossible for me to hear and bear it [the Passion] in mind, without forming mental images of it in my heart. For whether I will or not, when I hear of Christ, an image of a man hanging on a cross takes form in my heart, just as the reflection of my face naturally appears in the water when I look into it. If it is not a sin, but good to have the image of Christ in my heart, why should it be a sin to have it in my eyes?[6]

---

5. Calvin, *Institutes* 1.11.12, in *Calvin: Institutes of the Christian Religion*, vol. 1, trans. F. L. Battles, ed. J. T. McNeill, Library of Christian Classics, vol. 20 (Philadelphia: Westminster Press, 1960), p. 112.

6. Luther, "Against the Heavenly Prophets in the Matter of Images and Sacraments (1525)," in *Works*, vol. 40, ed. and trans. C. Bergendorff (Philadelphia: Muhlenberg Press, 1958), p. 99. See also *Works*, vol. 53, p. 416.

**3.2. Predella of the Wittenberg altarpiece in the Church of St. Marien, Wittenberg, Germany**

Giraudon/Bridgeman Art Library

Luther readily accepted the crucifix in his own church, and we can see a number of paintings from his own time that consciously illustrate his attitudes, including the famous painting of Luther preaching Christ crucified, which is part of the predella of the Cranachs' Wittenberg altarpiece (fig. 3.2 on p. 64). Luther, like other late medieval Christians, found the visual image of the suffering Christ to be indelible and essential to an ardent devotional life.

Finally, in large part as a response to the varieties of Protestant criticism of images, the Catholic reformers at the Council of Trent re-emphasized the value of images for the edification and devotional life of Christians while at the same time carefully distinguishing images from idols, consciously following the wording of the Second Council of Nicaea (787): "Thus it follows that through these images which we kiss and before which we kneel and uncover our heads, we are adoring Christ and venerating the saints whose likenesses these images bear."[7] Consequently, the images of the saints, Mary, and Christ were revived and used to foster personal piety and encourage religious fervor among Christian believers. Those who encountered it in its new religious venues were powerfully affected by the beauty, glory, and even ecstasy of the art that emerged in seventeenth-century Italy, France, and Spain.

### Real Idolatry, or the Reason for the Problem

At this juncture, I should perhaps point out that from a historical perspective the concerns of the anti-icon factions (both Byzantine and Protestant) about the pagan roots of image veneration had an arguably legitimate basis. At the time of the foundation of Christianity, traditional Roman polytheists did *appear* to worship images, and thus visual art *was* associated with paganism and idolatry (cf. Paul's speech on the Aeropagus in Acts 17). The sculptural depictions of the gods were often treated as much more than simple artistic representations, although probably not as "containers" for the divine nature. The images were worthy of veneration because such honor was extended to the divine being that they portrayed. They were the focus of pro-

7. Council of Trent, second decree, 25th session, in *The Church Teachers: Documents of the Church in English Translation*, trans. J. Clarkson et al. (St. Louis: Herder Book Co., 1955), pp. 215-16.

3.3. Bust portrait of Constantine the Great, from the Basilica Nova, now in the Museo del Palazzo dei Conservatori, Rome

cessions, prayers, offerings, and sacrifices. They received garlands of flowers and were placed in shrines. Initiation into some of the mystery cults included an epiphany of the god — a sacred and precious appearance that was stimulated by proximity to the image itself. Cult images didn't need to be realistic, or beautiful, or even ancient. Miracles and wonders were attributed to them — from the winning of battles to the cure of illnesses, from predicting the future to staving off famine. When Christians claimed these same properties and powers for their saints' images, they might well have seemed to be reverting to traditions associated with polytheism.

The image of the Roman emperor at the time when Christianity was emerging had significant parallels to the theology of icons much later. The ruler's likeness carried the weight of presence or of identity (fig. 3.3 on p. 66). From a practical standpoint, the emperor's image could be in several places at once, and could act as a kind of proxy for the man himself. People who offered prayers or sacrifice to a likeness understood that they were offering it directly to the original (in this case the reigning emperor), through the medium of his "genius" or guiding spirit. In the early days of the church, when Christians refused to honor such an image, they did so because they defined such activity as idolatrous. The Romans regarded this as unpatriotic and persecuted the non-compliant, sometimes throwing them to the wild beasts in the amphitheatre.

A century or so later, when the Roman emperor had converted to Christianity (ca. 315) and when paganism itself was on the wane, Christian theologians could even dare to compare the image of the emperor with that of the divine Logos, since they both shared in the nature of their source or model:

> How then, if they are one and one, are there not two Gods? Because the imperial image, too, is called the emperor, and yet there are not two emperors . . . since the honor shown to the image is transmitted to its model. And what the image is down here by virtue of imitation, so the Son is over there by his nature.[8]

Images were far less threatening when they no longer signified the dominant religion of a persecuting power, and by the late fourth century, defini-

8. Basil, *De Spiritu Sancto* 157.44, trans. C. Mango in *The Art of the Byzantine Empire*, p. 47.

tively Christian images had been around for more than two hundred years. Just like the students in my audience at that Catholic university, these later Christians would see images as dangerous only when they were of someone else's gods.

Before that time, however, when early Christian writers attacked the practice of image veneration, they usually referred to pagan images, not to Christian artworks. To the extent that they warned their audience against idols, it was the snares of non-Christian culture that they meant. In fact, Christian artworks may have been relatively unknown to these writers, since recognizable or distinctly Christian art appeared relatively late. No existing widespread tradition of Christian figurative images can be dated before the early third century. Thus certain behaviors that directly or indirectly involved images of the pagan gods were *de facto* instances of idolatry. Actors or theatergoers, for instance, would automatically be tainted by idolatry via the salutation to the patron deities of the theater before the drama began. Painters and sculptors, along with actors and even teachers of classical literature, were barred from baptism until they could demonstrate that they had left professions that produced, used, studied, or even brought them into proximity with images of the pagan gods, whether visual or textual.[9]

To a limited extent, Christian arguments against idolatry drew upon the repudiation of religious iconography in Jewish tradition. However, they also referred to classical, non-Christian philosophical objections to polytheism in general and image worship in particular.[10] Combining such venerable anti-image traditions made the case against idols stronger and more persuasive, particularly to those in the audience who would have been less moved by Jewish proscriptions than by arguments based on highly respected philosophical principles. Even Paul did something of this sort when preaching from the very center of philosophical learning: he appealed to the Athenians' intellectual pride and cited their altar dedicated to an "unknown god" (Acts 17:16-34). Like Paul, Christian writers also drew a contrast between pagan practice and Christian aniconism. They pointed out that Christians do not think their deity "is like gold, or silver, or stone,

9. See, for example, Hippolytus, *Apostolic Tradition* 2.16.

10. See, for example, Justin Martyr, *First Apology* 5 (citing Socrates' efforts to deliver humanity from the demons) and 9 (on the folly of idol worship).

an image formed by the art and imagination of mortals" (Acts 17:29). But not thinking that the deity is like a gold or silver statue cannot be equated with being opposed to the making of art — even figurative art.

The only indisputable evidence for an early prohibition of visual art in a Christian context comes from a local church council held in Elvira, Spain, around 305 C.E. Two translations of the Latin of the relevant canon are possible. The first option reads, "There shall be no pictures in churches, lest what is reverenced and adored be depicted on the walls." The second translation takes the verb and makes it the noun of the second clause — "lest what is depicted on the walls be reverenced and adored."[11] If we follow the first translation, the text might demonstrate a concern about protecting the mysteries of the faith from being seen by the uninitiated, not a clear edict against any kind of representational art in the church. The second translation leads us to conclude that the canon aimed at preventing possible confusion of the image with its prototype and a potential misunderstanding or misuse of images.

Whatever the case, we have good evidence that by the early fourth century, such pictures had started to appear on the walls of Christian churches. The prohibition itself would hardly be necessary otherwise. The Christian building at Dura Europos with its frescoed baptistry is a good example. After Emperor Constantine's conversion to Christianity initiated an imperially-sponsored building program, the situation changed substantially, and the practice of gloriously decorating churches with images of the saints, biblical narratives, and rich symbolic iconography got fully underway. Simultaneously, attacks against idolatry began to fade, certainly in part because the surrounding culture was gradually becoming Christian (and thus less threatening), but also because the pagan gods were gradually disappearing from the scene. By the middle of the fourth century, the focus of Christian theological polemic shifts away from the dangers of pagan idolatry to the threat of Christian heresy. A perceived problem with visual art or Christian image-making more or less disappeared for the time being.

---

11. Council of Elvira, Latin text and translation in C. J. Hefele, *History of the Christian Councils,* trans. W. Clark (London: T&T Clark, 1894), p. 151. The problem of alternate translations was discussed by M. C. Murray, "Art and the Early Church," *Journal of Theological Studies,* n.s., vol. 28, no. 2 (1977): 229fn.2.

## *Idol or Art? A Continuing Problem*

In the early centuries, and during the Byzantine icon controversy, the objections to Christian images mostly focused on the way they were understood, their origins, and their function far more than on what they portrayed. The danger of visual art was that it be might be misunderstood to be something that it was *not* (worthy of worship or adoration). However, once visual art was accepted as an appropriate aid for Christian pedagogy, devotion, and theological expression, then the problem of content arose. The problem of *what* then complicated the debates about *whether* Christians could make and use images in general. Certain images could still be judged unacceptable and destroying them justified, while others were allowed to remain. Even though they might be acknowledged to be human-made objects without intrinsic power, particular artworks might still offend or frighten because of what they pointed to or promoted. The Protestant Reformers wished to purge the church of what they deemed superstitions, and to the extent that images were associated with popular practices that offended them, the images had to go. For example, in the late 1520s, the leading reformers of Strasbourg demanded that the city magistrates remove the idolatrous pictures in local churches, in particular the images of the saints to which people continued to pray and offer veneration. By contrast, these same reformers were willing to allow other images they did not deem idolatrous to remain, including portrayals of Christ's Passion and the purely secular coats of arms that served the arguably corrupt but merely worldly aims of honoring certain local families.[12]

A similar debate has arisen about whether the national flag belongs in the sanctuary of a Christian church in this country. Those who object argue that the inclusion of a political emblem in a sacred space grants it a parallel or equivalent significance with the cross, the altar, and other sacred objects. Besides confusing the sacred with the secular realms, they claim, to venerate this particular symbol or to invest it with religious value is a form of idolatry. Moreover, declaring allegiance to a nation has no place in the worship of a God who transcends human borders and partisan battles and

12. See the discussion in C. Christensen, "Patterns of Iconoclasm in the Early Reformation," in *The Image and the Word*, ed. J. Gutmann (Missoula, Mont.: Scholars Press, 1977), p. 116.

**3.4. God, from the central apse of the Cathedral of the Incarnation, Nashville, Tennessee**

asks for our ultimate loyalty. Placing a national flag inside the church might be like early Christians allowing images of the emperor in their house churches. Placing such images in a worship setting could justify an iconoclastic response. And, indeed, the very fact that certain people could view flag-burning as criminally "disrespectful" only serves to demonstrate an idolatrous confusion of faith with patriotism and the nation that the flag symbolizes with the transcendent and supreme authority.

In recent years, feminists have called our attention to the arguable idolatry of exclusively male pronouns, titles, and images for the Godhead. A prominent representation of God the Father as an old man with gray hair and long beard in the church presents a problem that may not be explained away by appeals to the comfort of tradition or the anagogical function of metaphor (fig. 3.4 above). To many minds, such representations not only limit the divine nature to a particular human appearance but also have contributed to the oppression of women by suggesting that men are created in

the image of God in a way that women are not. Charges of blasphemy, heresy, and even abuse could be made in regard to such images, and if they are prominently displayed in the worship space, their removal or destruction could be justified, despite their sentimental value or artistic merit.

David Freedberg, in his book entitled *The Power of Images*, discusses a number of modern cases of iconoclasm, including a 1978 attack on Nicolas Poussin's 1634 painting *The Adoration of the Golden Calf* as it was hanging in London's National Gallery.[13] The attacker slashed the canvas with a knife, concentrating his efforts on the central figure of the calf mounted on a garlanded altar. Freedberg comments that at the time, no one noted this fact — indeed, that museum officials seemed dumbfounded by the act, since they could see no reason for the selection of this particular work for destruction. To them the attack seemed entirely random and senseless. The painting was described as being a "beautiful work of art," unlikely to be the source of any particular outrage. As Freedberg points out, to understand why such a painting could cause offense, one would have to consider the subject matter — the story of the idolatrous golden calf itself. The slashing of that particular painting (though undoubtedly the work of an individual who was mentally unstable) has a kind of pious logic. The image itself asks the viewer to be outraged, to condemn what is being portrayed, and to say — or act — a loud "no."

We can insist that objects in themselves do no harm to the immutable divine. Yet they may do harm to us, and for that reason we need to take care about those things we may unconsciously mistake for something they are not. The church has always condemned idolatry, but how do we define it? What do we label as an "idol"? What kind of religious art or other object could be put in this category? In the Orthodox tradition, the defenders of icons very firmly assert that images and prototypes are two different things. Images are not holy in themselves but rather are a means by which a viewer can be put in touch with the divine — with the wholly other. Icons are special tools or aids for meditation that are particularly effective because they reveal a truth or present a reality that might be grasped in some other way, but not so easily or directly. At the very least, the icon is a focus for prayer (directed at the image and passing to the original); at most it is an effective means of making an invisible reality more perceptible to the one

13. David Freedberg, *The Power of Images: Studies in the History and Theory of Response* (Chicago: University of Chicago Press, 1989), pp. 421-23.

open to and eager for the divine presence. In this view, images are as effective as printed or spoken words — perhaps for some people, even superior to words — as a means to perceive the presence of the holy in the world.

The danger lurks when we can become attached to certain kinds of tangible or material presence, especially if we are particularly attracted to their beauty or value. Whereas words are understood by most people as linguistic constructs that are limited descriptions of reality, pictures have a concreteness and a beguiling beauty that may lead a viewer to forget that they are not ultimately real and to confuse the object with the truth that lies beyond it. Dance and music performances exist in time and then disppear. But we can *own* images, keep them as treasures for their own sake. We cannot do this in quite the same way with books. We can possess books, but we can't own their ideas or stories. However, some books (rare books — or even the Bible) may also become idols if they are treated as objects independent of their contents.

This leads us back to the operational definition of idolatry: mistaking the image or symbol for the thing it represents, forgetting that its true function is to point beyond itself and coveting it for its pure physicality or its crass material value. Mistakenly worshipping an object as if it were more real than the idea that it points to commits us to lies and mistaken loyalties. Somehow, we think we can possess beauty itself, a belief that can only lead to avariciousness, terror of loss, and ultimately despair when we realize that even if our grasp has no limits, we ourselves do. And since we can't take our "stuff" with us, we should resist delighting in material objects for themselves alone and turn instead to the truths that they point to, that they lead us to perceive — from the eyes to the mind and the soul. The prophet Habakkuk spoke immortal words of warning: "What use is an idol once its maker has shaped it — a cast image, a teacher of lies? . . . See, it is gold and silver plated, and there is no breath in it at all. But the LORD is in his holy temple; let all the earth keep silence before him!" (Hab. 2:18-20).

Yet, if we reject the lie and instead aim to be led upward from the image to the truth, we will be supported by the central teaching of Christian theology: that in the Incarnation — in the person of Christ — we are allowed to *see* God as well as to *know* God. This act of divine self-revelation actually requires us to construct a theology of vision as well as to define a role for visual art that asserts both the limits and the value of the image. Moreover, we are called to testify to the *seeing* as well as the *hearing* of the truth. In the words of First John: "We declare to you what was from the beginning, what we have

heard, what we have seen with our eyes, what we have looked at and touched with our hands, concerning the word of life — this life was revealed, and we have seen it and testify to it, and declare to you the eternal life that was with the Father and was revealed to us — we declare to you what we have seen and heard so that you also may have fellowship with us" (1 John 1:1-3).

Moreover, while the Incarnation was a unique instance of divine self-revelation, it was not the *only* instance when God was made visible in or through the creation, known to us through sight, sound, touch, taste, and smell. Creation bears and reveals the imprint of its maker, even if most of us are not the recipients of more direct epiphanies in burning bushes or descending doves. We know God through all our senses, not because we have no better way but because these are our receptive organs — God's gift to us so that we might have many ways of knowing and declaring the truth that we hear, sense, taste, and *see*.

Nevertheless, visual images raise special concerns, not only because we might mistake earthly things for the spiritual truths they point to but because of their great power. We may be confronted by a vision we aren't entirely ready to engage but can't escape, or we might find a deep consolation or inspirational beauty that we joyously embrace. Some images are unforgettable; they will remain etched in our memories even if we want to erase them. Images have a way of startling us by their presence — of looking back at us, affecting us, sometimes even upsetting us in unexpected ways. While words indirectly refer to images that we make in our imaginations, images are right in front of our eyes and communicate directly. Nor are they easily manipulated or ignored. Whether beneficial or destructive, images are immensely potent. They change us because their message is expressed in a graphic form that is tangible in a way that words spoken or heard are not. And, in the end, words are merely substitutes for the images they represent, and those images serve as aids to memory when we want to keep ideas or stories in our minds. We don't remember printed sentences, but we do remember the pictures they create in our imaginations. Like Luther, we simply cannot purge our minds of images and will continue to make them in our imaginations, even if we no longer see them in front of our eyes.

Given their power and their danger, we must take care about the images we destroy and the images with which we live our lives. We must remember that they are not ends but means to an end. We will both see and know, which is why, after all, seeing *is* a means to believing.

# 4  Beyond the Decorative and Didactic: The Uses of Art in the Church

In the early fifth century, Paulinus, a Roman aristocrat first turned monk and then made bishop, built a new basilica in Nola, Italy, near the grave of a local martyr named Felix. The site soon became a famous pilgrimage center. Paulinus, however, came to have certain regrets about the popularity of the shrine he had erected, as it began to attract more sightseers interested in feasting and pouring libations at the tombs than pious pilgrims devoted to prayer. In a conversation with a visitor to the shrine, the aristocratic bishop revealed his discomfort with the development:

> Now the greater number among the crowds here are country folk not without belief but unskilled in reading. For years they have been used to following profane cults in which their god was their belly, and at last they have turned as converts to Christ out of admiration for the undisputed achievements of the saints performed in Christ's name. Notice in what numbers they assemble from all the country districts, and how they roam around, their unsophisticated minds beguiled in devotion.... See how they now in great numbers keep vigil and prolong their joy throughout the night, dispelling sleep with joy and darkness with torchlight. I only wish they would channel this joy in sober prayer and not introduce their wine cups within the holy thresholds.... Their naivety is unconscious of the extent of their guilt, and their sins arise from devotion, for they wrongly believe that the saints are delighted to have their tombs doused with reeking wine.

Confronted with a pastoral problem, Paulinus decided to commission a series of painted (or perhaps mosaic) images portraying Christ, the saints,

and a variety of biblical stories. It was, according to him, a somewhat un-usual project. The purpose of these artworks was to entice visitors inside the walls of the church and away from the feasts at the martyr's grave:

> This was why we thought it useful to enliven all the houses of Felix with paintings on sacred themes, in the hope that they would excite the inter-ests of the rustics by their attractive appearance, for the sketches are painted in various colors. Over them are explanatory inscriptions, the written word revealing the theme outlined by the painter's hand. So when all the country folk point out and read over to each other the sub-jects painted, they turn more slowly to thoughts of food, since the feast of fasting is so pleasant to the eye. In this way, as the paintings beguile their hunger, their astonishment may allow better behavior to develop in them.... As they gape, their drink is sobriety, and they forget the longing for excessive wine.[1]

Clergy today might have some doubts about how well Paulinus's method would work for them — whether a really good art collection would bring worshippers in and turn their minds from feasts to prayer, and sober them up for service to God. On the other hand, how different are today's megachurches with their impressive attendance records, their video screens, and their emphasis on popular music? Perhaps new forms of contemporary liturgy that incorporate the persuasive appeal of film, video, and print graphics (including the world of advertising) are really just the modern counterparts of Paulinus's art display. We could argue that the higher and more long-term goals of religious conversion or transformation might ini-tially be best served by this use of popular media. There is no doubt that such media have a power the more traditional forms lack to draw in "seek-ers" and those new to religion, who are comfortable with — even reassured by — familiar forms from their sophisticated secular culture.

Paulinus, like pastors through the centuries, faced competition in his theological marketplace. He responded by providing a kind of competing attraction. However we judge it, we have no reason to doubt that his mo-tives were genuine or that his goal was achieved. Along with enticement, he

1. Paulinus, *Poem* 27.580, in *The Poems of Paulinus of Nola*, trans. P. G. Walsh, Ancient Christian Writers Series, vol. 40 (New York: Newman Press, 1975), p. 291.

also provided inspiration, and through it — according to his account, anyway — he converted some of his flock to a more pious life. He didn't do it simply by verbal exhortations or regular catechism classes. He introduced multimedia by adding visual art to his outreach technique. And it worked.

On occasion, I have asked church groups to recall a significant worship experience — one in which everything seemed to come together. I give them a few minutes to remember one very powerful example and to try to identify one or two aspects of the service that made it so important, memorable, or moving for them. Then I ask individuals to describe the event in some detail to the rest of the group. Inevitably, I find the worship experiences described were vivid and unforgettable — as much or more because of particular nonverbal elements than because of words preached, prayed, or even sung.

The stories told are remarkably consistent in certain respects. They describe moving Tenebrae and Sunrise services, Palm Sunday processions, baptisms on the beach or at the Easter vigil, healing services, and communion meals at family dining tables and in fellowship halls — which all include some particular use of the arts. Such services are often marked by a dramatic use of light and darkness. They incorporate effective visual symbols, special rituals, powerful musical and dramatic elements, or they take place in significant settings. Usually associated with important festivals (e.g., Christmas Eve, Maundy Thursday, Easter, and Pentecost) or life passages, they are already rich with potent memories. Key themes are embodied and interpreted through story, music, gesture, and image. Sound, smell, color, texture, movement, and light all make the action and atmosphere of these worship experiences powerful, memorable, and even transformative, particularly insofar as they contribute to the unfolding of a drama.

Such unforgettable worship moments are rare; perhaps this is what makes them so effective. What we learn from such creative worship services has more to do with the ways that different modes of expression, including non-verbal ones, carry and communicate both our strongest convictions and most powerful emotions even on more "everyday" occasions. We need to understand and incorporate effective and important tools, just as Paulinus did — although not just by adding a few gimmicks to attract people initially. Christian worship can be visually as well as verbally rich, filled not only with prose but also with poetry, enhanced by all kinds of art forms, appealing to all the senses. The church that ignores these important

tools or modes of worship not only loses an opportunity to embrace fuller and more meaningful worship forms but also, in the end, imperils itself. If we cannot or will not learn lessons about the importance of visual and sensory communication from the secular culture around us (à la Paulinus), our worship will seem completely out of touch — unrelated to the ordinary life experience of most Christian churchgoers.

This is not a new argument. After all, the arts have always been essential to the church, and the varied arts that the church has used to propagate the faith are shown even in its founding documents or scriptures. Jesus, for example, taught in parables and metaphors. The Hebrew scriptures are filled with stories and poetry, with references to music and dance, with descriptions of lavish art and architecture. The description of the New Jerusalem in the book of Revelation is truly sublime. In commissioning his murals, Paulinus may have had in mind the beauty and opulence of Solomon's temple or the gathering of the saints around the throne of the Lamb. The first Christians painted the walls of their tombs — and then also their churches with pictures that proclaimed their faith. Among the images of biblical figures were beautiful compositions of vines, birds, and flowers. The liturgy was elaborated to include processions, chants, and solemn rituals. Like the priests in Solomon's temple, the clergy donned special garb to add to the splendor of the setting.

This ancient, sanctioned relationship between Christian worship, theology, and art has another side, however. Instances of friction — even direct conflict — between artist and institution are almost as common as examples of cooperation and appreciation. The works of visual artists have been viewed with suspicion, confusion, and fear by church authorities who denigrated the visual arts and suppressed them as much as encouraged them. As art became more and more a part of secular culture, especially in the Protestant churches after the sixteenth century, a kind of chilly distance grew between many church bodies and the artists in their communities. The church sometimes withdrew its patronage or attempted to dictate acceptable forms, prompting artists to look elsewhere — to public institutions and private patrons. And as artists turned to the privately wealthy and privileged classes of society for support, they inevitably became part of a culture of elitism that grew up around museums and galleries, especially in urban centers. When this happened, the church as an institution was in danger of losing something crucial: its imagination.

Somewhat ironically, the reasons underlying the discord between church and artist might now be seen as potential bases for restoring a positive relationship. Whether this can be done depends on how we evaluate certain core theological principles that have been used both to defend and to deny the role of art for the life of the church, particularly in certain traditions. Let me raise four areas of possible misunderstanding and friction, which also happen to be four areas in which the visual arts have been used and still potentially can be used as sources of renewal and transformation.

### Art as Decoration

The first of these areas of friction as well as potential positive value is art's decorative function. On the problem side of the equation, because it is hard to speak of "decoration" as anything serious, art has sometimes been deemed "non-essential." "Decorative" art in particular has been and often is presumed to be frivolous, distracting, unnecessary, and/or self-indulgent. Congregations can be torn apart over their conflicting viewpoints on this matter. On one side are those who argue that the church, in its pristine purity, rejects the "trappings" of art and architecture and worships the invisible God in simplicity rather than splendor. This side usually prefers offerings of good works to beautiful objects. They represent a "righteousness of the plain" that views art as the beginning of a slide down into vanity, materialism, and — ultimately — idolatry. Added to this is the perception that art is expensive and "extra," something that drains money from more essential programs. This is a challenging argument when resources are limited and needs are pressing. To spend money on art is perceived as selfish or uncharitable in the face of other urgent matters, which may have priority in terms of immediate need. A text from Isaiah is often cited to make the point: "When you come to appear before me, who asked this from your hand? Trample my courts no more; bringing offerings is futile; incense is an abomination to me. . . . Cease to do evil, learn to do good; seek justice, rescue the oppressed, defend the orphan, plead for the widow" (Isaiah 1:12-13, 16-17).

Associated with this line of argument, I believe, is the assertion that beautiful "things" are distracting to the eye and thereby disturbing to the soul. Art is somehow seen as "carnal" rather than "spiritual." We are at-

tracted to the worldly beauty that we see rather than being drawn inward or upward to the invisible and spiritual. This attraction seduces us — it draws us down from lofty matters to material ones. Moreover, art addresses the senses, awakens appetites, and arouses passions. Its affective qualities are unpredictable and destabilizing. Understood in this way, art can tempt us to sin, like the serpent in the garden. Those who espouse this point of view see religion as the sober, rational, and dispassionate activity of a human mind seeking knowledge — not a proper sphere for feelings or sensory experiences.

A theologian might argue, however, that this disequilibrium is just what religion requires. Encountering the beautiful leads us out of our stale patterns of belief and into new ways of thinking. Our response of delight and gratitude draws us back to the essential goodness and beauty of creation, helping us to appreciate that shared beauty in all living creatures as well as the external world. True beauty draws us toward love, and love to good works. Moreover, the experience of seeing a beautiful thing undermines our negative pride and self-reliance. We can be awed and lifted up to the contemplation of higher things, if only because we wish to be found worthy of the great gift of the material beauty we behold. In the same way, encountering an image of terrible sadness, horror, or even ugliness can motivate us to compassion and action in ways more effective than any verbal exhortations.

From their side, artists have difficulties with the use of the term "decorative." Calling art "decorative" seems to minimize, trivialize, and even insult it. Art is certainly not about mere "prettification." Words like "ornament," "embellishment," and "adornment" misrepresent and diminish the work of the artist as an adjunctive rather than essential activity. To explain what they do is to speak of the necessity of beauty in all its dimensions — not limited to "loveliness" — and the importance of visual metaphor. As a visual form of communication, art is absolutely essential. Visual expression is as basic to our worship as prayer is, a significant way that we offer honor and praise to God. When we make art, we give back the firstfruits, the best that we have, to the source of all good. The act is one of return, an offering of gratitude for the abundance of beauty given first in the Creation. The appearance of the worship environment in turn fundamentally shapes our experience of worship, in ways both conscious and unconscious. To the extent that art is present, the word is seen as well as heard.

Much could be said about the theological, ethical, and social symbolism of our worship space, but here I'm speaking primarily about the importance of aesthetic beauty. Beauty in the worship space is not intended merely to give pleasure to the congregant. It is there for the glorification and praise of the divine. If, as theologians assert, God is not only the Good and the True but also the Beautiful, then only through an experience of beauty may we fully know God. To be good and true ourselves, we need to bring the beautiful into our worship, formation, and fellowship as well. If we respond with delight and gratitude, certainly that is the right way to feel in the presence of the holy. If we respond with compassion and benevolent action toward the world around us, that too is the right way to be in the presence of the holy.

To speak of God as Beauty is to speak of a transcendent attractiveness, not a superficial one, of an awesome splendor and magnetic power that both humble and challenge us. The radiance and glory of God are revealed in nature as well as in the greatest works of art, and neither are necessarily comforting or pretty. Abbot Suger of the French abbey church of Saint-Denis in the twelfth century, one of the guiding spirits of the emerging Gothic style, did not want his building to be merely pretty; he wanted it to be dazzling (fig. 4.1 on p. 82). Suger's abbacy at Saint-Denis marked some of the greatest achievements of medieval art in the development of architecture, sculpture, and the stained-glass window. He opened up the ambulatory of the monastery church, letting the light flood the high altar. Suger's theology of light was dependent on the mystical writings of Pseudo-Dionysius. He saw his cathedral as the physical embodiment of that theology in which we encounter the divine through our spiritual illumination. He had no hesitation about using art and material beauty to express his faith and to symbolize the transcendent glory of God.

Suger, however, was criticized for the rich art in his church by those who opposed his use of precious materials and the making of opulent displays. Suger's artistic program for Saint-Denis seemed overtly sensual to some, undermining the pure spirituality of monastic piety. He defended the opulent altar coverings and the rich and costly furnishings of his church, asserting that they inspired devotion and that God was truly honored by the most beautiful of human creations. Suger inscribed a text on the doors of the church at Saint-Denis proclaiming that worshippers are led to the immaterial through the material:

**4.1. Interior of the basilica of Saint-Denis, Paris**
Copyright © Allan T. Kohl/Art Images for College Teaching

Whoever thou art, if thou seekest to extol the glory of these doors,
Marvel not at the gold and the expense but at the craftsmanship
of the work;
Bright is the noble work; but, being nobly bright, the work
Should brighten the minds, so that they may travel,
through the true lights,
To the True Light where Christ is the true door.
In what manner it be inherent in this world the golden door defines:
The dull mind rises to truth through that which is material
And, in seeing this light, is resurrected from its former submersion.[2]

Art was not merely showy adornment; it was a visual hymn of praise and a powerful devotional aid.

A different aesthetic was represented by a contemporary of Suger's, Bernard of Clairvaux, one of the early leaders of the Cistercian reform of Benedictine monasticism and a proponent of a new kind of monastic architecture. Favoring simple and undecorated spaces for monastic worship, Bernard rejected that which he deemed worldly and "carnal." He argued that extravagance in church décor showed disdain for God's command to care for the poor and the widow rather than to bring incense and offerings: "The church is resplendent in her walls, beggarly in her poor; she clothes her stones in gold, and leaves her sons naked; the rich man's eye is fed at the expense of the indigent. The curious find their delight here, yet the needy find no relief."[3] According to this argument, proclaiming God's glory through rich visual displays contravened the requirement to proclaim God's mercy and compassion. Raising dull minds to perceive the transcendent light came through works of charity, the pricking of conscience, and the humbling of pride. Luxurious, expensive, sensually pleasing works of art in the church were both spiritually distracting (especially for monks) and incompatible with a Christian life dedicated to charity and good works.

According to the Cistercians, art not only opposed a moral command-

2. The excerpt is from *Abbot Suger, on the Abbey-Church of St.-Denis and Its Art Treasures,* 2d ed., ed. and trans. E. Panofsky (Princeton: Princeton University Press, 1946), pp. 47-49.

3. Bernard of Clairvaux, *Apologia* (to William, Abbot of Saint-Thierry), translation taken from E. G. Holt, *A Documentary History of Art,* vol. 1 (Garden City, N.Y.: Doubleday, 1957), pp. 20-21.

ment but also constituted a distraction to the committed spiritual life. Renouncing materiality in the form of painting, sculpture, stained glass, and metalwork was necessarily a part of the monk's general renunciation of the sensual world — a core aspect of monastic discipline. In their rejection of the richness of Suger's style, however, the Cistercians produced another kind of aesthetic, sometimes called "artistic asceticism." The clean and undecorated spaces of Cistercian monasteries are as architecturally remarkable in their stark simplicity as Suger's Saint-Denis is in its ornamented splendor. Although the two styles are very different, one plain and the other ornate, both can be described as beautiful and inspiring — both categories that encompass a vast number of different styles and tastes.

And this is an important point. We may find beauty and inspiration through profoundly different styles of art. Perhaps an obvious contemporary aesthetic contrast, comparable to the medieval clash between Suger's and Bernard's aesthetics, is that between abstract art and representational art. Many twentieth-century abstract artists were oriented to spiritual values, although not to traditional religious values and even less to religious institutions. They produced works that emphasized color, rhythm, line, texture, and form more than content, and their "meaning" defies words and certainly varies from viewer to viewer. Wassily Kandinsky, for example, removed all traces of naturalism from his art, as did Piet Mondrian, although in an entirely different way and for different reasons. Whereas Kandinsky strove for transcendence through vibrant and almost disorganized color and movement, Mondrian struggled to reproduce something he might call "pure reality" through symmetry, geometry, balance, and gesture. Mark Rothko also worked with colors, although also very differently from Mondrian, attempting to capture the idea of mystery, the supernatural, and the sublime in the intensity and relationship of fields of glowing color. Modern church architecture tends toward the spare and bare, yet may still be splendid in its proportions, materials, and design — and no less costly to build than a more ornately styled building. Although it may seem odd to call certain minimalist structures "splendid," by their grand and dynamic simplicity they inspire awe and point to the transcendent.

Whatever its form or style, a work of art may be beautiful and inspirational, engaging our spirits and evoking delight, love, and wonder. And this is true whatever its context or its content. We cannot say that a work is religious merely because it appears in a church rather than a gallery, nor can

we identify its religiosity on the basis of its content. Even the most secular subjects may communicate profound religious values. Perhaps more significant than its subject matter is the way a work of art draws the eye and the mind to an awareness of a deeper and more profound reality, symbolized by such wordless cues as form, color, composition, light, and texture. These characteristics are not incidental to the content or meaning of a work or to the impact the image has upon us — whether we are looking at a glittering, jewel-encrusted reliquary, a composition of water lilies by Monet, or the highly polished black marble and simple lines of Maya Lin's Vietnam Veterans Memorial.

## Art as Didactic

The second area of misunderstanding derives from the generally well-intended but utilitarian view of figurative or pictorial art that pronounces it to be the textbook or scripture of the illiterate. Paulinus, who saw the visual arts as a way to attract the "rustics" into his church and away from the feasts, perhaps held this view. Whether this is a positive or negative opinion of art itself depends on the context and the proponent. People who make this argument probably don't really think that they are anti-art. In fact, they may see art as a good thing in certain circumstances. In my experience, people reason that pictures are good for telling stories to non-readers, and that illustrations are especially good for children. In fact, we hand out Bible-story coloring pages and crayons to children as a way of keeping them busy and quiet during long, wordy church services — roughly the same reasons that Paulinus painted pictures on the walls of his basilica. After all, children and non-readers learn imperfectly through images what adults and the educated grasp more fully by reading and hearing. Why else would we grow up to read books without pictures?

At the beginning of the seventh century, Pope Gregory the Great wrote a now-famous "defense of art" in a letter to Bishop Serenus of Marseilles, whom Gregory had admonished for destroying certain art objects he found in churches. Ironically, the argument Gregory offered for the value of images themselves could be construed as an actual disparagement of the images as well as of those who valued and used them. In his letter, Gregory explained the limited value of art in the worship space: "For pictorial repre-

sentation is made use of in churches for this reason; that such as are igno-
rant of letters may at least read by looking at the walls what they cannot
read in books."[4] Gregory recognized the potential of the images to educate,
but then went on to warn against idolatry, praising Serenus for prohibiting
the adoration of those images. Art had its function, even if that function
was very limited.

On the positive side, this argument sees visual art as supportive of
Christian education and nurture. Visual art in the church accomplishes
two things simultaneously: it provides inviting competition for other, less
edifying activities, and it is a useful didactic tool. Art is an effective attrac-
tion, and art teaches lessons, especially to those who can't or don't read.
Moreover, pictures may have value even for those who *do* read: they may
function as visual aids that supplement the text and reinforce and vivify it
through color and drama, light and texture. They offer an interpretation of
the narrative and foster a particularly vivid engagement with the story.

On the negative side, if visual art merely illustrates a text, it limits the
reader's imaginative engagement with the story by focusing on set images.
Despite the adage that "one picture is worth a thousand words," pictures
and words cannot be equated quantitatively; their work is fundamentally
different. Illustrations cannot reveal the whole narrative or all its meanings
any more than a verbal description of an artwork would make sense apart
from the work itself. And when an artist tries to produce a literalistic visual
synopsis of a text, the art suffers, since very simplistic or shallow images
usually result. For this reason, images simply cannot — and should not —
take the place of words. Although very different in the way they work, the
two modes (visual and verbal) are interactive and interdependent. As a way
of knowing the Scriptures, visual art *alone* is insufficient.

Good narrative art *is* about telling stories, but good *stories* do more than
impart information. Visual art, based on a story, offers a point of view, di-
mension, and amplification of the narrative, not a literalistic rendering of
it. The image has its own integrity as an interpretative form. It is not pri-
marily shaped by adherence to its source or judged by whether it accurately
reconstructs certain details in the narrative, as if it were subservient to it.

4. Gregory the Great, *Epistle* lib. 9.105; 11.13, trans. J. Barmby, in vol. 8 of *The Nicene and Post-Nicene Fathers*, second series, ed. Philip Schaff and Henry Wace (Grand Rapids: Eerdmans, 1969), pp. 23, 53-54.

The artist addresses a certain moment of the story and expresses it in an imaginative way, possibly even diverging from elements of the accompanying narrative in order to expand and expound its meaning. If the artwork does this, it both reveals and enhances the significance of the story in the lives of those who view it.

Paulinus's innovation was, perhaps, not as original as he thought. From the beginning, Christian buildings as well as burial places were enhanced with images made in mosaic, paint, and stone that presented episodes from cycles of Bible stories as well as images of the saints and the prophets. Their selection, composition, and arrangement may have been based on the calendar of feasts, the structures of prayers, the contents of catechetical lessons, or the order of Scripture readings. They assisted the memory by giving an event, a rite, or a story a particular visual cue, which over time affected, shaped, and reinforced key aspects, climactic moments, or core meanings of those events, rituals, and readings. From at least the sixth century on, certain narrative images were more directly tied to scriptures in illuminated Bible manuscripts. Illuminated manuscripts came to be a primary art form during the Middle Ages, and they clearly demonstrate the ways the visual arts imaginatively expound on and interpret text. Images also shape the rhythm of the narrative, in part by focusing on a particular moment within the text, requiring the mind to rest at a certain point and to experience a visual mode of "reading" the story.

In addition to interpreting familiar Bible stories, art in the church offered moral lessons. For example, the semicircular tympanum over the western portals of many Romanesque and early Gothic cathedrals contained a scene of the Last Judgment — a visual or graphic parallel to the exhortations offered from the pulpit or the preaching of mendicant friars. This scene chastened sinners and proclaimed the church door as the gate of salvation. Inside the church was a whole curriculum. Biblical scenes were joined by images of the saints and the prophets — the heroes of the church — that were meant to inspire viewers to imitate their lives of self-sacrifice and utter devotion (fig. 4.2 on p. 88). Historical events, both sacred and secular, were represented, and the aisles and chapels contained tombs, relics, and treasures. Parables appeared in the stained-glass windows.

Art at its best in this context interprets and inspires; however, history indicates that this has not always been the case. Sometimes moral lessons have been experienced as indoctrination, not challenge. And art in the

4.2. Romanesque statues of saints, south portal, Chartres Cathedral,
Chartres, France

church has often served the function of merely reinforcing a set of secular cultural values rather than presenting an authentically "Christian" or even biblical ethic. Religious art has always been subjected to both doctrinal and moral evaluation, in large part because it is so significant a tool for the formation and education of the community. In fact, artworks that misrepresented biblical stories or explicitly contradicted traditional teachings or morality have been rejected. The difficulty, of course, has always been discerning what is good art and what is not on such terms, since claims can be made that all kinds of conflicting values are truly "Christian" in nature. Some critics would answer that art ought not to engage in secular ethics at all, in order to be free of ideology and to be able to pursue pure aesthetic values, which have a value entirely independent of social or political "good." Of course, as far back as Plato, the conflict between the freedom of the artist and the formation of a moral (or Christian) society has been impossibly vexed. Unfortunately, the two ends of the spectrum — that art should serve the purposes of a prescribed doctrine or morality, and that it should abstain from engaging, supporting, or challenging religious or social values — are both flawed. But this much is clear: the art in our churches is by definition religious and thus must address or reflect certain values. The role of the observer is to be consciously aware of those values and to evaluate them for their validity in light of other theological and moral teachings.

One of the values of art as a pedagogical aid is its effectiveness for training the memory. Visual imagery is a tremendously valuable tool for religious instruction because it works. Children both learn and remember their lessons when pictures accompany them. This is also true for adults, but because the technique seems "childish" or unlearned, it is often neglected, even in these times of widely accessible and flexible electronic and digital aids. Moreover, the fear of breaking the Second Commandment, the rule against making "graven images," still causes some Christians to repudiate visual art, even for instruction, although less fearful Protestants make exceptions for pictures that have a pedagogical purpose. Here again there is historical precedent. Many of the early Reformation paintings were clearly designed to be "lessons in color" and often included the Scripture verses the images referred to. Luther wished for a fully illustrated Bible for the edification of the laity, even advocating biblical images painted on the walls of houses "for the sake of remembrance

and understanding."[5] On the other hand, while Calvin recognized the pedagogical value of images, he worried that they were as effective in teaching falsehoods as truths and could be abused. He explicitly contradicted Gregory's thesis.

In his book *Visual Piety*, David Morgan comments on this odd contradiction in traditions that otherwise deny the religious value of visual art:

> Even among adults who feel that images are inappropriate within the worship space of the sanctuary, memories of religious education include the profuse use of images; nor did anyone voice opposition to the use of images in training children today. This discriminating iconophobia appears to be connected to an epistemology that regards rudimentary or childish thought as concrete and figurative, and sophisticated or adult thought as immaterial and abstract.[6]

Morgan goes on to discuss "The Bethel Series," a Bible-study program adopted by evangelical Christians in the late 1950s that included paintings as mnemonic devices. The illustrations were designed to visually encapsulate specific dogmatic assertions about God's providence, as distilled from passages in the Bible. By way of reassuring the teachers who used the program, the series editors specifically denied that the illustrations were "art pieces," asserting instead that they were "merely tools to help the student remember and retain what he has learned."[7]

We may conclude that Gregory was right about art teaching lessons, but not only to the illiterate. Visual art is an essential tool for faith formation and the communication of key concepts, core principles, and cherished traditions. The images on the walls of a church, the symbols in the sanctuary, and the artworks hanging in the narthex contribute to the message preached from the pulpit, whether or not the congregation con-

5. Luther, "Against the Heavenly Prophets in the Matter of Images and Sacraments (1525)," in *Works*, vol. 40, ed. and trans. C. Bergendorff (Philadelphia: Muhlenberg Press, 1958), p. 99.

6. David Morgan, *Visual Piety* (Berkeley and Los Angeles: University of California Press, 1998), p. 185.

7. Morgan, *Visual Piety*, p. 185. The quotation is taken from "A Description of the Bethel Series and a Statement of Its Objectives," in *The Bethel Series* (Madison, Wis.: Adult Christian Education Foundation, 1961), p. 2.

sciously pays attention to them. The illustrations in a Sunday school curriculum, the fronts of bulletin covers, and the illustrations attached to daily meditation manuals all affect the ways people hear or read their sacred stories and shape their conception of the divine. Once we carefully evaluate these nonverbal modes of expression and communication, we may find ourselves surprised by the power they have to project and then reinforce particular ideas and values — ideas and values that may be quite satisfactory to us, or that we might want to reconsider.

## Art as an Aid to Devotion

Many — if not most — representations of biblical stories in art contain details that seem incongruous, anachronistic, or purely inventive on the part of the artist. We often see historical figures placed in contemporary settings or biblical characters in modern costume. Landscapes and domestic interiors look unlike anything we might expect if we were striving for historical accuracy. From the fourth century to the present, however, artists have not felt constrained by such historicity, a fact that sometimes bruises the sensibilities of modern viewers. Baby Jesus appears with reddish-yellow hair on the lap of the brocade-draped Madonna, who has very lovely blue eyes. The inn at Bethlehem is surprisingly fitted out with tableware characteristic of a seventeenth-century German hostel. In the Merode altarpiece by Robert Campin (ca. 1378-1444), for example, the central panel shows the Virgin sitting in a comfortable domestic interior (the sitting room of a Flemish burgher), reading a book as the Angel Gabriel approaches with his announcement. On the right wing of the altarpiece, Joseph busily carves a mousetrap (a reference to the Atonement) in his well-appointed workroom. On the left wing, the donors of the painting approach in an attitude of reverence, looking as if they are about to intrude, like unexpected neighbors, on an intimate scene (fig. 4.3 on p. 93). Most of us are not distressed by these liberties with the narrative, for we realize that Campin was not trying to construct a historically or textually accurate representation of the Annunciation, but rather seeking to represent its significance and to capture a particular mood — the breath-catching tension of this particular moment.

The incorporation of contemporary details into such paintings of biblical stories actually encourages the viewer to enter the scene, to be a part of

it. Similarly, ancient pilgrims visiting various sites in the Holy Land imaginatively and literally placed themselves in the biblical settings and, once there, read through the appropriate stories so as to join historical time with the present. They were there in Martha's kitchen or in the Garden of Gethsemane. In the same way, artists from ancient times to the present have invited us to enter the picture without necessarily entering a time-travel machine. We do not simply stand off to the side and observe but show up in the scene. That the visual presentation of the scene is contemporary serves as a particular means of invitation and then incorporation.

In the late Middle Ages, efforts to revive and deepen the spiritual life of both the religious as well as ordinary Christian folk produced a series of devotional exercises designed for both cloister and laity. For example, in the early fourteenth century, an anonymous Fransciscan friar wrote a devotional manual known as the *Meditations on the Life of Christ*. This type of manual had antecedents in the writings of Bernard of Clairvaux and Saint Bonaventure, as well as later parallels in the *Imitation of Christ* by Thomas à Kempis, the *Windesheim Canon*, and the *Spiritual Exercises* of Saint Ignatius of Loyola. The *Meditations on the Life of Christ* emphasizes the importance of the imagination by asking the reader to enter the story as one of the participants. In this way the narrative becomes a present — not a past — event. For example, when the writer recounts the story of the Magi arriving at the manger, he elaborates on the scene to include touching details — and vividly drawn characters — in inviting language. He then urges the reader to "go and stand beside" the shepherds, and once they have left, to enter the stable:

> Do you also bend the knee, you who have so long delayed to come, and adore the Lord, your God, and afterwards venerate his mother and reverently salute the holy Patriarch Joseph? Then kiss the little feet of the infant Jesus in his cradle, and beg of Our Lady to let you take him into your arms. Take him, then, into your arms, keep him there, earnestly look into his face, reverently kiss him, and take delight in him with all confidence. . . . Afterwards give him back to his mother, and attentively observe how wisely she manages him, how she feeds him and does for him all little services.[8]

8. *Meditations on the Life of Christ*, attributed to St. Bonaventure, ed. and trans. M. Emmanuel (St. Louis: B. Herder, 1934), pp. 36-37.

**4-3. Merode altarpiece at the Cloisters, New York City**
Metropolitan Museum of Art, The Cloisters Collection, 1956 (56.70)

Similarly, the Devotio Moderna, a lay movement that emerged at the end of the fourteenth century in northern Europe, gathered circles of educated middle-class women in their homes to read devotional manuals. The eventual invention of the printing press sped this process along, but even before this time, devotional manuals were available for pious circles of lay men and women to read, and images of the Virgin learning to read at her mother Anna's knee and holding a book as the angel entered her chamber to announce the Incarnation became popular iconographic motifs. Female saints are often shown reading as well. The devout reader could then see the activity of the Virgin and the saints as a model for her own activity, an activity carried out in a domestic setting, perhaps not unlike the interior depicted in these paintings.

By making the setting contemporary with the world of the viewer, the paintings, like the devotional exercises, asked the onlooker to become actively engaged in the scene — to join with the crowd running along with palms at Jesus' entry to Jerusalem, to stand with the witnesses at the crucifixion. The pictures were intended to make the observer into a participant. Francis of Assisi had the same goal when he developed the first manger scene and the Stations of the Cross, a combination of visual and prayerful meditations on the walk Jesus took to Golgotha. In time, wealthy private patrons commissioned devotional paintings for private use as well as altarpieces for their parish churches. These patrons had themselves included in the compositions, perhaps to see themselves as present in the moment as well as to be in the picture permanently. Often this meant that the characters in the paintings were far removed, historically, from the biblical setting. By inhabiting the scene in an imaginative way, viewers could experience past events as if they were present and contemporaneous.

An entirely different devotional use of art comes from the Orthodox tradition of praying with icons. Apart from the festal icons that represent certain biblical scenes for the days of their commemoration, Orthodox icons are portraits and not based on narratives. As portraits, they are not meant to be realistic in the usual sense of the word. The icon's likeness exists only in the fact that it directs the worshipper to the model that it represents, a model that we can recognize in part because of a long-standing set of rules guiding the attributes, colors, and garb appropriate for each individual saint's representation. By certain standard aspects of composition, the icon painter communicates the holiness of the image. Of course, each holy image

is given a halo, but in addition the face is given a thin, elongated nose, a proportionally small mouth, and large, almond-shaped eyes that usually look directly at the viewer. Backgrounds are minimal and not intended to create illusionistic space or depth; thus perspective is often broken or inverted. The icon does not record a particular appearance so much as focus the concentration of the prayer and help one feel the invisible presence of the one to whom the prayer is addressed. Thus the viewer and the image interact, but in this case the viewer is not invited into the image so much as invited to look through it, to allow the image in a sense to serve as a medium of a prayer directed to a different reality than the painting itself.

A movement away from narrative and representational work and toward pure symbolic and abstract forms marks much of twentieth-century visual art. For certain artists, subject matter was supplanted by an emphasis on pure form or color as the bearer of meaning or significance. Realistic content was jettisoned. Color and texture, line and shape were alone allowed to hold and transmit an idea, which might be deliberately inarticulate. Out of this came a different kind of devotional art that invited viewers to interact with the elements and composition of the painting itself rather than enter a narrative scene. The composition no longer mediated an imaginative exercise; instead, it encouraged a more directed encounter with the artwork itself, on its own terms, without any background "text" or narrative.

Viewers who are untrained in how to look at this kind of art can feel lost without a recognizable subject. They don't know what to make of a picture that tells no story and don't know how to engage a visual image that presents itself as only a play of form and color, line and texture. All the usual reference points are missing. Yet, properly understood, this art has the power to invite contemplation and to aid the mind to meditate on the divine precisely because it eliminates distractions. These paintings are not trying to represent something that we can find "familiar." They are self-revealing and self-referenced, not without content, although that content lies beyond ordinary verbal articulation.

One of the most deeply religious or spiritual of these artists was Mark Rothko, a twentieth-century Russian-born artist whom I mentioned earlier. His paintings are luminous — though superficially simple — interplays of color, presented in squares that seem to magnetically draw the eye. These intensely emotional paintings might be actual visions of the transcendent realm — heaven itself — understood in terms of palpably sensual

and profoundly considered collaborations of brush and paint. The banishment of the figure was absolutely necessary to this kind of subjective vision. Rothko's work challenges the viewer to contemplate the painter's experiment with color and form and to discover an ecstatically beautiful combination of pigment, material, and light, and in that contemplation to have what he might have called a "religious experience."

We could liken this emphasis on the absence of subject to the iconophobic denigration of the image: the fear that representation will be misunderstood for reality. Such work might also be related to the theological assertion that God is invisible and unknowable in human form or earthly analogies. In Christian mystical traditions this could be called *apophatic* theology, or the *via negativa*, which aims at a knowledge of God by denying that anything we assert or image about the divine could be true. Such a method asks us to erase the figures, the symbols, and the metaphors from our minds in order to confront the incomprehensibility of the divine nature — to know by knowing its unknowability. In a sense, art that exchanges representation and symbol for pure abstract form strives to bring us beyond words, and perhaps even beyond concepts. Perception is enough. Referring to them as "theologians of nothingness," one commentator recently described the work of the abstract expressionists, especially that of Barnett Newman, another color-field painter: "They pushed their way through to a cloud-enshrouded Mount Sinai, where the backside of the Glory can be sensed more than seen or heard."[9]

## Art as Prophecy

More recent artists appear to be rediscovering subject matter, especially the human figure, and re-introducing the idea that art can deliver a message. The human situation — from ecstasy to tragedy, grief, and loss — appears in the works of contemporary artists, especially those who might speak of their work as having religious content. At the same time, many of these artists have produced images that incorporate symbols, figures, objects, and

9. Charles Pickstone, "'Though it be night': Barnett Newman at the Tate," in *Art and Christianity Enquiry Bulletin* 32 (October 2002): 2. Pickstone credits Harold Rosenberg with the term "theologians of nothingness" in particular reference to Newman.

scenes that aren't so much aimed at being religious as they are at telling truths. The goal is some kind of conversion of conscience or awareness, awakening of compassion or impetus to action. These artists are advocates, and their work is often intended to shock or shame. This brings us to the fourth and last area of discord in as well as promise for the church: the prophetic role of art.

In a sense, the prophetic role is related to the didactic role of art, but it goes further and in a particular direction. Rather than reinforcing the teachings, stories, or values of the church, the artist may challenge the church and confront the viewer with disturbing images which raise profound moral questions that religion cannot ignore. These images may be drawn from Scripture, but they are just as often drawn from scenes in the modern secular world. Thus, art can be more than a transmitter of tradition or dogma — it may be a social critic and even an agent of change or liberation. Such art points the viewer not to the transcendent or the divine realm but rather to the human plane, calling attention to contemporary problems. Art in this case has a moral urgency and an ethical purpose.

Confronting viewers with disturbing images gets their attention, even if it upsets them. Injustice, oppression, and violence are subjects that visual artists grapple with as much as theologians, journalists, social workers, and politicians. Moreover, the graphic representations that present the results of these social evils are sometimes harder to ignore — or to forget — than the printed accounts in newspapers alone. Artists use their particular tools to call attention to individual and communal evil — the disjuncture between espoused values and practice — and to overcome apathy. Prophetic art provokes, criticizes, and prompts action, especially when the work is both disturbing and demanding and — as my generation might say — "in your face." Unconcerned with conventional ideas of beauty, this kind of art can be frightening, grotesque, and ugly. Some people don't like it and want to avoid it, while others are strangely drawn to it. Calling this kind of work "prophetic" doesn't mean that it isn't edifying or even pious, however. Indeed, some would say that "prophetic" art is the *most* edifying or pious — even the most devotional — kind of art. Some would even say it's the most authentically "beautiful" because it is the most manifestly "true."

Not just a recent development, this art has much in common with other examples of "advocacy art" from earlier eras. We can see examples of this in Rembrandt's eventeenth-century works that highlighted the sorrow

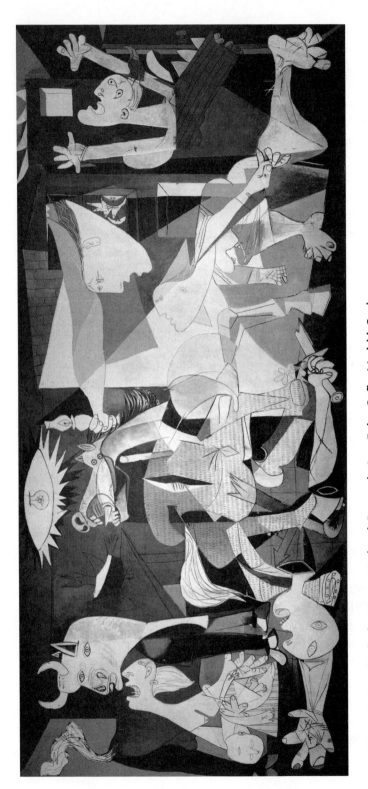

**4.4.** Picasso's *Guernica*, in the Museo Nacional Centro de Arte Reina Sofía, Madrid, Spain

Bridgeman Art Library

of the Jews of Amsterdam, and in the early nineteenth-century etchings and paintings of Francisco Goya (1746-1828) that showed the horrors of war and the follies and brutality of his generation of Spaniards. Goya's harsh look at his society was carried on by the realists of the next generation, such as Honoré Daumier in France (1808-1879); his work also clearly inspired Picasso's famous anti-war masterpiece, *Guernica* (fig. 4.4 on p. 98). The social criticism of some of the realist painters of the mid-twentieth century found its counterpart in one of the most influential tools for social change: the camera, and more recently the video camera.

Dissatisfaction with things as they are drives artists to produce images that don't represent things as they might be in some utopian vision but are expressions of shock, pain, outrage, or disillusionment intended to produce a similar reaction in viewers. The "shock art" of recent decades may be a result of this dissatisfaction. The subject matter need not be realistic, although photography has contributed a whole body of images of this type. Nor does it need to be contemporary or secular in its subject matter. In fact, many of the most important examples of this kind of work contain religious themes, one of the most prominent being the Passion or crucifixion of Christ. This subject has been used to suggest the suffering of the oppressed, the horror of war, and the loneliness of the martyr. Christ has been portrayed as a victim of a totalitarian regime, an oppressed worker brutalized by life in a capitalist society, a prisoner of conscience who spoke out against a corrupt system, a freedom fighter, and simply a disillusioned human soul. Christ might be a victim of AIDS or of racial prejudice. Christ has also been portrayed as a woman on a cross, to some minds a scandalizing image, to others a powerful one. Viewers of this attention-getting image may judge that women have been battered by a dominant patriarchy, by sexual exploitation, or even by the church itself, just as Jesus was betrayed, silenced, and finally sacrificed by his community.

The power of visual images to impact the social and political realm is very well demonstrated in the way that propaganda works. Politicians as well as marketing specialists well understand the value of art "with a message." We will have to be careful, however, to discern the difference between prophetic art and propaganda, which, depending on the viewer's ideology, might amount to the same thing. Any "message art" can be superficial and sloganeering, whatever position it takes with regard to the mainstream culture or dominant political powers. I believe that the difference

between propaganda and prophecy is that the latter opens up a conversation and refrains from prescribing a single response. The goal of the prophet is to call forth personal transformation, not to sell a particular product or idea. Prophetic images as well as the reactions to them are complex and vary from viewer to viewer and from time to time. People who use visual images to market products or ideas, on the other hand, are strategically focused on achieving a particular reaction. Art that comes out of social critique often describes more than it defines and lets viewers decide for themselves how they feel about what they see.

Since this work is often "ugly" rather than conventionally beautiful, challenging rather than didactic, and usually controversial, congregations may avoid displaying it in the center of their communities or worship spaces. The issue isn't so much about matters of taste or even about doctrine as about our religious and ethical values. We have to "decide" how to respond to the art, since it isn't there primarily to comfort, fascinate, or edify us. We don't judge it on the same terms as other kinds of artworks, and it may not be as lasting as other works if its content is especially topical or timely. On the other hand, the goal of the artist is not necessarily to make a work that will last forever but one that will portray something true.

Artists work with dark and sometimes frightening truths, and so long as we have artists, they will continue to portray the horror of our world as well its beauty. Our spiritual life will not be healthy if we overlook or ignore human suffering, and so religious artists will exhort us in a visual mode just as a preacher might in words. Still, it will take a great deal of courage for churches to accept these difficult images and place them where they confront their congregations. Even where people have come to accept the decorative and extend the value of didactic or devotional images, prophetic images can remain problematic. However, if we are honest with ourselves, we recognize that the formation of faith — and the transformation of the church — will happen only when we are fully integrated: when we live both in and outside of the world, both loving and challenging it.

Art, if it is to have any use for the church, must be vital and dynamic, relevant to the lives we now live. It can affect us and even change us by addressing us at intellectual, emotional, ethical, and spiritual levels. Art can delight our eyes and inspire devotion. Art can deepen our understanding and enrich our worship. It can soothe, delight, and set us on fire.

# 5 Holy Places and Sacred Spaces

Jacob was sent on a journey by his father, Isaac. He left Beer-sheba, his parents' home, and traveled to the place of his ancestors, his mother's family, by way of Haran, the place where his great-grandfather Terah had settled, the place God called Abraham to leave. Jacob was traveling back into his family's past, retracing their journey from Ur to Canaan. Along the way, he stopped to rest for the evening and slept on the ground under the stars, with only a stone for his pillow. In his dream he saw a ladder that stretched from the earth to the heavens, with angels of God descending and ascending upon it. And God spoke to Jacob in his dream, saying, "I am the LORD, the God of Abraham your father and the God of Isaac; the land on which you lie I will give to you and to your offspring. . . . Know that I am with you and will keep you wherever you go, and will bring you back to this land." When Jacob woke, he knew that this was sacred ground: "Surely the LORD is in this place — and I did not know it! . . . How awesome is this place! This is none other than the house of God, and this is the gate of heaven." Then Jacob rose, took the stone he had used for his pillow, and set it up to mark the spot where he had seen the ladder rising to heaven. He poured oil upon it and named it Bethel, meaning "House of God."

Based on Genesis 28:10-22, this familiar story recounts the discovery and dedication of a holy place, one where the divine presence has been manifest, a place that is a gateway between earth and heaven, complete with ladder to allow the angels and the imagination to ascend and descend. This place was on the itinerary of a journey, a pilgrimage from present to past and then to the future. And this is what a sacred space is: a site where earth and heaven meet, where time and memory merge, and where we

have a means to rise and descend through an open door to the unknown and the eternal. This biblical story recounts how a particular space came to be set apart from the mundane world in a permanent way. How different this was from the experience of the tribe of Israel, wandering through the wilderness, carrying the portable symbols of the sacred with them. In that case the sanctuary came along with the people, a tent that could be pitched and a tabernacle that could be set up wherever the community rested. Later, when the community was settled, the permanent resting place would be identified, dedicated, and elaborated with precious metal and stone.

Sacred space is an abstract idea. It is like sacred image, and yet very much unlike it. Its symbolism lies not so much in its content as in its form. With space we move from the picture to the frame, finding the shape of the idea by noting its edges. Like Alice through the looking glass, we may enter this image and explore it, because it opens up into three dimensions. As we enter, we find a world beyond the frame as passages lead us to new spaces, as doors open into rooms unseen from the outside. We no longer stand at a safe distance and observe; now we are physically contained by the picture itself, and we have to decide where or how far we will go into it — whether we will turn to the right or the left, go into the places we didn't see before, when the frame blocked our view. Moreover, space is sometimes permanent and sometimes transitory. A sacred space may move with the community, especially a community in transition, as Israel was in the wilderness.

Up until now I have usually used the term "visual art" to refer to what we could call graphic art: drawings, paintings, and prints in which two-dimensional images constituted of color, line, shape, and texture are presented to the eye in the nonverbal language of symbol and figure. Inspired by observation of objects in the exterior world or by memories contained only in the internal/mental world, these images were shaped first in the imagination and then projected onto flat surfaces — painted or drawn on canvas or plaster or carved into stone slabs. While these images might give the illusion of depth or dimension, they cannot be entered, walked around, or (usually) even viewed from the side or the back. Unlike Alice, we cannot actually enter the picture and be drawn into its world. A skilled artist might create the appearance of depth, distance, or volume, but we aren't usually fooled by the illusion. We stand in front of the image and gaze at it from a certain distance, which varies according to our need to focus the eyes, see a detail up close, or take in the whole at once.

**5.1. One of Gehry's structures: the Weisman Art Museum,
University of Minnesota**  Gayle Graham Yates. Used with permission.

Most sculpture allows us to walk around and view from different an-
gles, and to a certain extent so do relief carvings and art objects made of
glass or other transparent materials. But by and large these are solid forms.
Huge or small, open or impermeable, they remain essentially separate from
the viewer, interacting as "other." It is true that architecture and sculpture
share certain attributes, and that the differences between them can some-
times be blurred, as in the structures of Frank Gehry (fig. 5.1 above). My
point is that architecture is an art form that we can enter and in fact *must*
enter to understand. Since architecture still projects an idea, it is a symbol,
or image, but it is also more than these: it is a place, a destination, a "site."
Architecture has an interior and an exterior, doorways and walls that en-
close or define a whole environment. We visit and leave — or return or re-
main. Our experience of this art cannot help but be physical because our
bodies are actually inside of it. We feel it, smell it, and hear it as well as see it.
In fact, the presence and interaction of people is essential to the design.
This kind of art cannot be seen all at once. We behold it only partially, a sec-
tion at a time. We cannot see both inside and outside or back and front at
the same moment.

A photograph of a building such as we have seen here is still a two-dimensional thing. We really cannot experience the image at all by this means, because here we see only one aspect, section, or angle. We do not know what it would be like to be inside except by constructing the experience in our imaginations from the photograph, or by reconstructing a particular visit in our memory. Moreover, the photograph gives us no certain idea of the scale of the actual structure. We could be mistaking a doll's house for a mansion. Drawings or photographs of sacred spaces are thus inadequate for any understanding of the real thing, for unlike other two-dimensional images, they refer to something that makes sense only in terms of its extension in space (form and dimension), its mass (density and scale), and its penetrability (solidity).

All architecture is a kind of icon, and this is especially true of religious architecture. It manifests an idea in nonverbal form, functioning as a symbol at the most mundane and the most profound levels. Since spatial design here is symbolic, even the most utilitarian of buildings, such as a storage shed built to serve a religious function, can be a religious image, a religious symbol. And buildings consciously constructed to have symbolic value must be seen even more clearly on these terms. Depending on the way it is viewed, a religious space may mediate or contain the holy presence in almost the same way that a traditional icon, painted on a wooden panel, might do. Perhaps more than other kinds of structures, buildings that are put to sacred uses are especially concentrated symbols, on a par with the domestic building: a house, or even our original home, the womb.

## The Church Building as Home

Churches, synagogues, temples, and other places of worship are often called "houses" of worship. As a child, I always thought this a bit odd, because they didn't look at all like houses to me — at least not like any house I might live in or visit. But the association of house with religious architecture is ancient. Common Latin expressions for a church building include *domus Dei* (the house of God) and *domus ecclesiae* (the house of the assembly). That early Christian churches met in houses is a point on which most archaeologists agree. Eventually, some of these "house churches" were renovated to accommodate larger gatherings. In these places of hospitality,

early Christians gathered to share a meal together, not unlike a gathering for a dinner party in a private home. Clearly, domestic space is essential to the idea of Christian architecture, part of its deep memory. Here the community was first nurtured.

The house, as a deeply significant symbol, taps into our most primal memories and shapes our dreams. The symbol of "house" points to far more than a structure or building. Insofar as it serves as the geographical base for the family, it becomes a "home." "Home" in its turn suggests the nest, or mother, the place of our safe and welcome returns, but also the goal of our travels. In dream language, the house is a metaphor for the self, for the soul or spirit. Rooms and doors are openings into the new and possible — or they could be closing us in or shutting us out. We discover hidden or forgotten chambers, wander down corridors, climb stairways to higher places, or descend to the depths or catacomb-like basements. We may invade spaces where we may not feel safe or belong, like Goldilocks — and fear discovery. The house, with its walls and doors, chambers and stairways, is a profound metaphor for our consciousness. Not only does it store our past; it is also the stage of our present and the projection of our future.

In his fascinating analysis of this subject, *The Poetics of Space,* Gaston Bachelard reflects at length on the symbolic and spiritual meaning of the house. He describes his subject in this way:

> Now my aim is clear: I must show that the house is one of the greatest powers of integration for the thoughts, memories, and dreams of mankind. The binding principle in this integration is the daydream. Past, present, and future give the house different dynamisms, which often interfere, at times opposing, and at others stimulating one another. In the life of a man, the house thrusts aside contingencies; its councils of certainty are unceasing. Without a house a man would be a dispersed being. It maintains him through the storms of the heavens and through those of life. It is body and soul. It is the human's first world. Before he is "cast into the world," as claimed by certain hasty metaphysics, man is laid in the cradle of the house. And always, in our daydreams, the house is a large cradle.[1]

1. Gaston Bachelard, *The Poetics of Space,* trans. M. Jolas (Boston: Beacon Press, 1994), pp. 6-7.

Bachelard understands that the house is only one possible metaphor, but because of its primacy as shelter and its intimacy, its sense of a mother's embrace, it holds a symbolic power or force that no other space can.

The analysis Bachelard applies to the symbol of the house could easily be applied to the church as a house. The church is the place of birth in Christian tradition. It is mother and it is shelter. We are born in its womb and nourished in it as in a cradle. This is especially symbolized in the architecture and liturgy of baptism, where the font represents the womb of the mother church. The church as house or mother forms our memories and establishes our deepest values, even if we move out and on. And ultimately we return to it in death. The symbolism of this space is vast and rich, dynamic and powerful, and perhaps more than a little scary. After all, the church may be a "house," but it also a "sacred" or "holy" place. And it is the place of our spiritual reintegration and sustenance. When we go back, we expect to receive a welcome.

Architects who work with worship spaces — from preservation to renovation to building from the ground up — recognize these complex connections and intimate memories. They know that most individuals are powerfully affected by their memories of childhood churches and that many clients often expect, assume, or just wish that the "church" would look like the one in which they grew up — the one that seems like the one at "home." Like the old song "The Little Brown Church in the Vale" reminds us, no other place is so "dear to our childhood," perhaps not even our "home sweet home." Architects dare not overlook this critical dimension of religious space — its sentimental (or even negative) associations in the memories of their clients. Americans are an especially mobile people that longs for roots and tradition. Thus "family" becomes extended to include congregation and clergy and the community, to include the dear departed — even the saints and the angels. The past and the future, childhood and old age, cradle and grave, marriage and birth, heaven and earth — all are brought together in this place. This is no ordinary building; it is tradition captured in wood, concrete, brick, or stone. Such attachments can limit architectural invention and creativity if clients' preferences for particular historic styles (however functional or nonfunctional they might be) are too entrenched. On the other hand, almost no other kind of space excites so much passion and engenders so much potential affection.

## The Church Building as Theological Symbol

But as much as space deeply and fundamentally shapes us, we also shape and reshape it according to our needs, beliefs, and identities. Being consciously aware of how much our worship spaces reflect, enhance, contradict, or undermine both our ways of *thinking* (theology, values, identity) and our ways of *acting* (liturgies, mission, service) allows us to take initiatives to make our sacred symbols and spaces compatible with who we are and what we believe. As a very large religious symbol and the context for our liturgical activities, the worship space both proclaims and manages. Unfortunately, sometimes it sends messages we do not intend and inhibits our activities. Thus, careful observation is the first order of business. We can learn to see more critically, analyze the spaces in which we gather and worship. We may discover that changes are needed and thus adapt our spaces in ways that better express and serve our communities.

While ancient polytheists saw a temple as a building that housed the image of the god and provided a platform for public sacrifice, Christians understand the church primarily as the gathering place of a community for common worship and a variety of social activities. From this perspective, the congregation is a subset of the broader local community, like a large family unit; its space provides a home base and an enclosure for its identifying behaviors. The space itself, by means of its placement, design, and furnishings, literally concretizes the values, traditions, theology, social location, and distinct characteristics of a congregation. The church building concentrates and communicates all kinds of nonverbal messages about the community that gathers around and in it. At a time when homes are less permanent and hardly ever handed down from generation to generation, church buildings increasingly come to serve the function of perpetuating, preserving, and protecting the traditions of a community.

Three general characteristics are common to all sacred spaces, and especially to churches. These are significant cultural, theological, and social determinates. First, the building defines *territory*. By virtue of its having walls, the space creates a boundary — a separation between inside and outside, and thus between groups of people (insiders and outsiders). This division of space may also define a separation between the mundane and the sacred. Entry into the building can signify a change in both status and geography. We are members of a select group, inhabiting a particular pre-

cinct. The boundaries are protective and defining at the same time. The space may be specifically consecrated and so even more "set apart." Structures keep us safe, keep us together, and keep us distinct all at the same time.

The division of space can be further broken down according to issues of access and status. Functional roles are assigned to particular places. Kitchen, office, and choir loft each have their usual activities and regular inhabitants. In almost every kind of religious space — and this has been the case from ancient times — special spaces may be limited to special ranks or grades of individuals and correspond to recognition of different levels of sacrality within the space itself. Certain persons are authorized to enter certain zones, while others are discouraged from doing so. Sometimes the boundaries are more permeable, and individuals are seen as more or less "out of place" in one or another location. Thus, some places are reserved and closed, some have limited access, and others are open. For instance, certain areas in some churches are reserved for clergy. Other places are specifically designed to accommodate and welcome children. Certain divisions exist to define and set off the holy space from the ordinary or profane, while others preserve order, support essential functions, and reinforce traditions.

In addition to establishing an enclosed and ordered space, the church building also represents a certain kind of *destination*. A church building is not a neutral place where just anything might happen. We rarely go into a church casually, accidentally, or merely "pass through," but rather go with a purpose, having certain expectations or hoped-for outcomes. Some churches are shrines, sited on "holy ground." These are places with a past, the setting of a story or particular historical event to which they are a connection. Being there allows us to walk in the footprints of ancestors or saints, to close a time gap with our imagination, and to provide our memories with an actual venue. These are also places with a particular presence; they shelter our relics and our treasures. If we arrive at a site with an awareness of its significance, its meaning will envelop us, and perhaps we ourselves will impart the meaning that we find. But even if they have no particular memorial aspect or no claims to be the site of a particular holy event or object, church buildings are places "set apart," settings for particular events or even for "ordinary" daily visits.

The destination sought often is the focal point of the interior of the building, or at least one of its main features. We have to enter to find it. However, even those who are not members of the community often iden-

tify the exterior of the church building as a place of reference and a place of gathering. Certain external features (bells, clocks, graveyards, green spaces) are shared with those who are not actual users or members of the church and contribute to aspects of civic self-identity. For this reason, sometimes even a small change to the exterior will upset neighbors as much as members or regular "inhabitants." Church building committees can be surprised by the vehemence of their neighbors' objections to renovations or rebuilding projects. In this sense, then, churches are public buildings too. They are part of the secular landscape and serve as community landmarks.

Finally, even while these buildings are destinations, they are also *passages*. They encourage movement as much as they reinforce identity and crystallize memories. The church space marks out the pilgrim's itinerary as well as points to the pilgrim's goal. The design of the interior, however subtly, provides a path from the periphery to the center, past and through a variety of life transitions, and from the secular to the sacred. The building as sacred symbol traces a possible route through time and through space, from birth to death, or from earth to heaven. Just as the walls of the building act as boundaries, and the center (or focal point) of the space may represent a destination, the arrangement of space becomes a map with compass points and marked roads in the guise of doors, aisles, ambulatories, barriers, and elevations. Light and darkness also serve as directional aids. The visitor enters, progresses forward, around, inward or upward, sometimes past a font at the door symbolizing the entrance to the life of faith, into the main nave where the congregation worships and toward the cross, pulpit, lectern, or table — representing the movement of God toward the people.

### Christian Sacred Space in Historical Perspective

From the beginning, Christian church buildings were different from the sacred buildings of their surrounding cultures. At first, remember, they were houses: Christian assemblies met in private homes owned by members of their group. In time the houses were renovated, and rooms were redesigned to better serve a growing community or a gradually more elaborate liturgy. The house church was a modest, practical, and available architectural form. Evidence suggests that the house was not a specifically selected model but rather was a space that could be used and then adapted according to need.

**5.2. Reconstruction of Christian baptistry, Yale University Art Gallery, Dura Europos Collection**    Yale University Art Gallery

We know that many such structures were adapted and used throughout the early Christian world, although apart from the Christian building at Dura Europos (fig. 5.2), our evidence for them is primarily textual.

In fact, it would be more accurate to say that the first Christians had no specific buildings at all. Christianity was an institution without architecture. Even as they met for worship in private homes (Acts 12:12; 20:8), Christians continued to go to the synagogue or the temple as they had before (Acts 2:46; 5:42). Other available spaces might be used as well. Paul taught in the lecture hall of Tyrannus for two years while he was in Ephesus (Acts 19:9). Paralleling the lack of extant early Christian art is the precious little evidence we have of Christian architecture before the third century, and even until the end of that century the data is scant and ambiguous.

Some historians have seen these unpretentious beginnings not so much as an indication of social status and community size or wealth but more as evidence that early Christians resisted the construction of special buildings for worship. Certain New Testament texts do make it seem that

the construction of a building runs counter to a core Christian teaching. For instance, in his final speech, Stephen reminded the elders and scribes that "the Most High does not dwell in houses made with human hands" (Acts 7:48). Similarly, when Paul preached to the Athenians on the identity of the unknown god, he made this clear statement: "The God who made the world and everything in it, he who is Lord of heaven and earth, does not live in shrines made by human hands" (Acts 17:24). We can add to these texts the scenes of Jesus cleansing and threatening to destroy the temple (John 2:13-22; Matt. 26:61), as well as Paul's metaphors of the body as the temple of God (1 Cor. 3:16-17) and the Christian community as the dwelling place of God (Eph. 2:21-22).

A popular fiction portrays Christians meeting in secret places or cata-combs, following a trail of "secret signs" to get there, in order to avoid the authorities who were continually persecuting them. Along different lines, historians of an earlier generation interpreted the paucity of evidence for early church building as proof that the earliest Christians were either indif-ferent or resistant to specific spaces for worship. This notion has been used to argue for the superiority of a faith that rejects the "trappings" of material culture. Paul Corby Finney summarizes this historical perspective by fo-cusing on criticism of the subsequent building of church structures: "What this development is supposed to reveal is a kind of spiritual recidivism: Christianity slipped back into pre-Christian (and anti-Christian) attitudes and forms of worship."[2] Recent scholarship, especially that of L. Michael White, has effectively countered such a perspective by showing both mate-rial and textual evidence of a kind of gradual but consistent development of architecture beginning well before the third century.[3]

As the community grew and became established and relatively more secure, especially just before and some time after the Decian Persecution of the mid-third century, the houses and house churches could no longer hold the numbers of congregants or accommodate the liturgy. For better or worse, the community was changing, and so was its architecture. The first specifically Christian buildings were simple structures, probably built as

2. Paul Corby Finney, "Early Christian Architecture: The Beginnings (A Review Arti-cle)," *Harvard Theological Review* 81 (1988): 328.

3. L. Michael White, *The Social Origins of Christian Architecture*, vols. 1 and 2 (Valley Forge, Pa.: Trinity Press International, 1997).

Christian assembly spaces, but without any distinct design or plan. Like the adapted house churches, they were relatively modest, practical buildings of a standard design adapted for a special purpose. Records show that some wealthier individuals or groups renovated entire apartment blocks, taking out walls and joining units together to create large, open spaces for the assembly. Eventually both the houses and these blocks (insulae) might be renovated again, made into permanent structures but still without set form or plan. Some of the so-called "titulus" churches of Rome were originally built along this plan, including the early assembly spaces of Saint Clemente and Saints Giovanni and Paolo.

Surprisingly, when Christians finally began to have a distinctive kind of architecture — just before and throughout the reign of Emperor Constantine in the fourth century — the architectural model was a civic or secular building rather than a specifically religious one. The basilica (hall of the king) was a combination of market, law court, and government building; its equivalent today would be something like a rather dignified and modest indoor shopping mall that also contains a registry of motor vehicles and a post office. The basilica was a large, open building, usually having an apse at one end and often divided into a central space with two side aisles defined by rows of columns that ran lengthwise down the center of the main room. Windows pierced the walls, sometimes above a gallery, so that the room was relatively light. The building might have doors on the long or short sides, but its focal point was the apse end, which contained a throne (or perhaps a statue of the emperor, the ancient equivalent of a picture of the president). This was an ideal Christian worship space for several reasons (fig. 5.3 on p. 113).

First, although such a building often accommodated a cult statue in its apse, it clearly differed from pagan worship spaces. It lacked the small inner room (cella) especially designed for the figure of a deity that could be seen only by consecrated priests on certain festivals. Nor was it rustic and primitive, like the sacred groves or crossroads with their outdoor altars and nature deities.

Second, the basilica was designed as an interior space — as a hall for limited and private assembly — rather than as an exterior stage for sacrifice before a large public audience. The liturgy of the church was a private and thus indoor activity. Christians "excused" the non-initiated from their sacred meals as a way of protecting the mystery and secrecy of the rites. The rite of baptism was likewise private: only the clergy and candidates (and

5.3. Interior of St. Apollinare in Classe, Classe, Italy

perhaps sponsors) were allowed to participate or observe. During the Eucharist, doors were closed, curtains were drawn, and prayers were mostly inaudible; explanations given to outsiders were sketchy. The building was designed to accommodate the crowd and its activities but also to provide shelter and privacy.

Third, the church building was the base of an organized and hierarchical community with several ranks of clergy and laity. People had a certain "place" within the system, and their place inside the building was defined according to their role or status. Liturgy reflected this hierarchy, and the building was adapted to create zones or spaces reserved for particular persons or groups. At the same time, the building served more mundane or daily needs. Morals were scrutinized, discipline was dispensed, and education was offered. The membership cared for the needs of its own — widows, orphans, the poor, and the consecrated virgins — through the distribution of food, clothing, and money. All these functions required specific spaces, appropriately designed rooms, and special furniture or other architectural features. A large rectangular building with side aisles and apse, along with attached rooms, served these needs very well.

And yet these early Christian buildings were also like other religious buildings in some ways. They were built to honor their God, to enhance the community's visibility, and to assert the superior efficacy of their cult and the values of the community. Once the age of persecution was over and Christians no longer needed to keep a "low profile," the era of church-building was fully inaugurated. Around the same time, a related development — the sacralization of particular spaces — became more important. In the past, the real estate had been chosen based on its availability rather than on particular holy or sacred associations. Now Christian buildings began to be sited in places of special significance to the communities, such as a martyr's burial place or a place with connections to sacred history — on land that was regarded as intrinsically holy.

For instance, the cemetery churches of Rome (e.g., Saint Sebastian's, Saint Peter's, and Saint Paul's outside the Walls) were built to accommodate pilgrims who were arriving to venerate particular shrines, especially those associated with the apostles Peter and Paul but also those of certain martyrs such as Agnes and Lawrence (fig. 5.4 on p. 115). Tombs were places of pilgrimage in part because of pre-Christian traditions of celebrating the anniversaries of the dead; those traditions were carried into Christian feasts of the

**5.4. Exterior of St. Lorenzo Fuori le Mura, Rome (as it looks today)**

saints. Pilgrims would arrive at the gravesite of a saint or martyr and hold a commemorative banquet there. Because saints were deemed to be different from other dead, visitors came to regard their graves (and physical remains) as places where the holy might be encountered and miracles sought. Such practices often disturbed ecclesial authorities, who were concerned about the often rowdy partying and drunken behavior associated with the feasts, not to mention the overly rapid expansion of the cult of local saints.

And so a compromise was reached. Increasingly, altars were placed over graves or relics, and the pilgrims continued to arrive at the holy places — sometimes in crowds large enough to require spatial management. Certain features of pilgrimage churches such as courtyards, transepts, aisles, and ambulatories were particularly designed to accommodate and direct the movements of a large number of people. The Christian architectural tradition grew out of a merging of an ancient funeral cult with the assertion that God enters and consecrates the events of human (not mythic) history.

Sacred history identified certain sites as particularly holy. According to tradition, Constantine's mother, Helena, had much to do with the identification and imperial patronage of particular sites in the Holy Land, in large

part by paying attention to local legends and traditions about certain places. First tourists, then pilgrims came to enter imaginatively and bodily into the sacred story by visiting the "actual" places where Jesus was baptized, where he taught and healed, where he was tried and crucified, where he rose from death. This was no ordinary landscape but one charged with the power of presence — a presence that miraculously lingered in the ground itself. Churches built at these sites were designed to accommodate pilgrims and to assist their re-creation of the past in the present.

Egeria, a fourth-century woman from Gaul, was one of these pilgrims. Happily for us, her travel journal has survived the centuries. Egeria made a grand tour of holy sites, stopping at Constantinople, Egypt, Antioch, and Edessa, as well as various places in Palestine, including Jerusalem. She was in Jerusalem for Holy Week in the 380s and described the liturgies she attended at the various holy sites associated with the Passion: the Mount of Olives, the Garden of Gethsemane, Golgotha, and the Shrine of the Resurrection. The meaningful intersections of Holy Week events with these special places were shaped by appropriate readings and dramatic enactments of parts of each episode.

The Saturday before Palm Sunday, for example, was called the Saturday of Lazarus. At one o'clock on that afternoon, the congregation was urged to meet at the Lazarium — "which," Egeria explains, "is Bethany, at about two miles from the city." She goes on to describe the place and the proceedings:

> About half a mile before you get to the Lazarium from Jerusalem there is a church by the road. It is the spot where Lazarus' sister Mary met the Lord. All the monks meet the bishop when he arrives there, and the people go into the church. They have one hymn and an antiphon, and a reading from the Gospel about Lazarus' sister meeting the Lord. Then after a prayer, everyone is blessed and they go on with singing to the Lazarium . . . where they have hymns and antiphons which — like all the readings — are suitable to the day and the place.[4]

On the next day the community gathered at the Mount of Olives to re-enact the entrance into Jerusalem. Egeria describes their coming down the

---

4. Egeria, 29.1, in *Egeria's Travels to the Holy Land*, ed. and trans. J. Wilkinson (Jerusalem: Ariel Publishing House, 1981), pp. 131-32.

mount singing and repeating "Blessed is he that comes in the name of the Lord," and she notes, "Everyone carries branches, either palm or olive, and they accompany the bishop in the very way the people did when once they went down with the Lord."[5] This ancient scene is still vividly re-enacted in many Christian churches on the Sunday before Easter. Processions around the nave — even outside the church and into the community — are continuing examples of this connection of time, space, and action. Just as in ancient times, even when pilgrims cannot get to Jerusalem itself, sacred space may be recreated in the imagination and projected onto proximate geography. And whether pilgrims make an actual journey or only an imaginative one, they bring and take away tokens or keepsakes to remind them of the "trip." Souvenirs are a part of the experience of a pilgrimage, a way of bringing a small part of the sacred ground back home.

## The Church Building as Expressive of Community Identity

The connections between sacred history and sacred geography — in particular the site of martyrdom or burial — are vividly apparent in sacred spaces that transcend the identities of certain religious groups or communities. In our day, some of the most significant public memorials are still those that commemorate a site of death or are actual graveyards. Gettysburg, Pearl Harbor, and Auschwitz are especially powerful examples. The Vietnam Veterans' Memorial has become a place of pilgrimage in large part because it records the names of the dead in a way that has given the inscriptions the status of precious relics. Native American burial grounds are places that have only recently (and sometimes reluctantly) been respected as sacred ground, barred from development. Pilgrims to these sites behave much as pilgrims always have. They place offerings of various kinds before the shrine and take home tokens as reminders of their visit. In the case of the Vietnam memorial, the visitors often take rubbings of the names of the deceased and leave mementos of the lost soldiers. The site of the World Trade Center bombings in New York City is a recent example of "holy ground" that belongs to no religious group but is indisputably sacred.

This sort of intersection of space with history (memory) and action (lit-

---

5. Egeria, 31.2, in *Egeria's Travels to the Holy Land*, p. 133.

urgy) shapes and transmits the identity and values of a community by embodying its central stories in symbolic forms. In this way architecture both externalizes and creates a particular worldview that belongs to the group that gathers within as well as without. Architecture does this in three dimensions: first, it expresses a group's particular social location; second, it provides the symbols of the group's particular identity and values; and third, it makes a "container" for its essential activities.

By the "social location" of a community we mean its place within a larger, more homogeneous culture and community. Material, social, and political security all are significant, as well as relative size and perceived social status. The Christian church, which began as a countercultural movement, was initially seen as culturally marginal, disruptive, and dangerous. However, as the church grew and expanded, finally moving to the center of the culture and being patronized by secure political power after the Constantinian conversion, its focus changed. And as the church achieved social, political, and economic security, its architecture moved from the functional to the monumental, and community worship moved out of converted available spaces into structures built specifically for this purpose. No longer seeing itself in a hostile world struggling to survive, the church began to turn its attention more inward — to matters of self-identity.

By providing symbols of a group's self-identity and values, architecture reflects the nature of the community from another angle. While social location refers to the way a community is identified with respect to its place in the larger culture, this focus emphasizes the way the community defines *itself* according to its own values, theology, and mission. Even Christian groups with similar ethnic or cultural composition can vary significantly in their defining theology, ideals, hopes, moral judgments, and vocation. To take an ancient example, second-century gnostic Christians may have *looked* like other Christians in their communities, and they may even have had similar liturgies, but they didn't *think* in quite the same way about Jesus or God, and they interpreted the sacred texts from an entirely different perspective.

Sometimes the community's theological or ethical identity is reflected in the style of architecture chosen for its buildings. Although some forms and styles are geographically or culturally conditioned, others are traditionally associated with the historic identity of particular sects or Christian

denominations and as such serve as visible markers to the larger society. A tall white steeple (often adorned with a clock) may be the identifying mark of a Protestant church; a dome usually indicates an Orthodox assembly. A neoclassical façade suggests that the institution embraces certain Enlightenment ideals. On the other hand, architectural stereotypes can deceive us. A neo-Gothic church might turn out to have an informal and contemporary style, and the most modern and starkly simple structure could be the sanctuary of a community with a sacramental tradition and highly complex liturgy.

Typically, however, architecture reveals a great deal about the theology and values of a Christian community through details that express fundamental doctrinal and ethical stances. For instance, a space may be designed to downplay the distinctions between clergy and laypersons, or to emphasize them by making particular areas within the church off-limits to nonclergy. The placement of altar (or table), baptismal font, and pulpit are also of momentous theological significance. In a place where Jews worship, the spatial center is the Torah shrine; for some Christians it is the altar. The decoration of the space also makes a statement about whether the congregation is part of a tradition that rejects figurative imagery in its worship space (on walls and windows in particular), or one that accepts visual art as a mediation of divine revelation, perhaps even on a par with the holy scriptures. Other visual symbols and details also reveal the particular character of a community. One of the most obvious of these is whether the church has a cross, crucifix, Bible, or set of organ pipes as its central focus point. When we enter a darkened or shadowy sanctuary with flickering candles, we encounter a very different atmosphere from a brightly lit nave with clear windows and a view to the natural world. In the candlelit church, the symbolism of light suggests the mystery of the divine, whereas in the other church the bright lighting seems to promise that the truth can be clear and accessible.

Other aspects of a community's life and ethical commitments are revealed by the apportionment of space inside its religious buildings. Large dining facilities indicate that community members enjoy eating together and might serve meals to hungry strangers. Well-appointed Sunday school classrooms demonstrate an emphasis on the educational ministry of the church. How the main assembly hall is used points to the congregation's attitude toward the space itself: whether it is to be set aside for the purpose of worship alone, or whether it may be multifunctional without overly chal-

lenging the sensibilities of the larger group. In a church comfortable with the latter emphasis, the hall sometimes doubles as an auditorium, a concert hall, or a community gathering space for secular activities.

In this way, achitecture serves as a container for a congregation's essential activities — its worship and its social life. The liturgical and social functions of a religious space should ideally inform its design, although often the relationship is reversed, and the space affects the functions instead. The space either "works" or "doesn't work" for the activities it houses. And when it doesn't function well, the architecture can hinder or undermine the purpose for which the community gathers, sometimes even forcing odd accommodations or adaptations of those activities. A well-known quip refers to the sometimes too-solid obstruction: "The architecture always wins."

Despite these impinging limitations, every tradition has a form for its worship and thus special requirements of its space and the furnishing of that space. Even the basic shape of the space is an important consideration. Certain communities require long spaces that allow movement and flow from back to front; they may also be concerned about the orientation of the building (east- or west-facing). Other communities worship more appropriately in settings that are shallow rather than deep, or even centralized — either round or square. Additional considerations that must be sensitively matched with liturgical forms include the level of light, acoustics, the inclusion of screens or dividers (chancel rail or iconostasis), and the placement of aisles, entrances (and exits), elevated platforms, and other features (baptistries, sacristies, side chapels, choir stalls, and so on).

While the space should serve the liturgical or ritual needs of a community, it may need to be redesigned or adapted as forms change and as the community's self-identity or theology evolves. Even the most permanent structures serving the most fixed liturgical forms will need to yield over time and be renovated, remodeled, or even rebuilt to serve new needs, forms, or developments that affect the composition of the community. Radical changes in the church's liturgy, self-identity, and social location took place in the fourth, sixteenth, and twentieth centuries (especially for the Roman Catholic Church after Vatican II), but these are only historical highlights in a constant stream of revision, reformation, and reclamation.

Since worship is a living and evolving medium even in the most traditional congregations, speaking to the present even as it honors the past, no

space that houses it can remain permanently unchanged as if it were a museum. Moreover, some theologians might point to that as a kind of idolatry. Today many congregations seek more flexibility and adaptability and less permanence in their structures. Sometimes communities must share their worship spaces with others. A worship space may need to serve part of the time as a secular meeting place or be transformed into a different kind of symbol for an entirely different community. Such a space comes to lose a certain element of particular identity as it adapts to or accommodates different kinds of groups or functions. The need for flexibility strains the way that particular place embodies and shapes the identity of a group, unless the group itself embraces the temporary or transitional nature of the space. Still, no matter whether they are permanent or temporary, our sacred structures symbolize the way we understand what we are called to do in this mundane and transient life, as we hope for a glimpse of the eternal and transcendent divine realm.

### Conclusion: Form and Function and Meaning

As we have noted, different architectural styles and forms carry certain enduring theological archetypes. Some of the structures that define sacred space are designed to suggest a civic utopia, where truth and justice are valued in this life. These spaces might evoke the values of the Renaissance or the Enlightenment by echoing neoclassical and ideal urban forms. As we enter them, we become citizens of the New Jerusalem. They have the appearance of a courtroom or a traditional academic building — a place that holds up the values of justice, knowledge, and the search for rationally determined truth. Other religious structures are meant to suggest the heavens or a celestial place of infinite, transcendent, and majestic beauty. These structures emphasize soaring heights or hovering domes so that the eye is drawn upward from the earth and trained on a place on high — either a cloud-filled sky or a starry firmament. The Gothic cathedral is one example of this type (fig. 5.5 on p. 122). As we enter these spaces, we are less citizens in a republic than humble servants at the gates of heaven.

A third possible type is the architecture that suggests the garden, a place of origin and of uncomplicated and unconstrained natural beauty. This is Eden, where we return in the end and where we rediscover our pri-

5.5. Interior of St. Vitus Cathedral, Prague

mal and essential union with nature. This may be a natural space with an intrinsic sacrality (and hard therefore to describe as "architecture"), or it may be a built space that tries to capture the idea of a natural environment. As an ideal of sacred space, the garden is the opposite of the perfect city. It is wild where the city is ordered and proclaims that the sacred is discovered (or reflected) in nature rather than the ordering of human communities, or found by transcending the earthly sphere in a shrine "set apart." In this "architecture" we return to the sacred grove or mound and leave behind the work of human hands. Such spaces depend, at the very least, on evoking the image of lush and verdant nature, as well as the presence of open air and running water.

Some religious architecture may suggest other kinds of community gathering spaces that may or may not evoke sacred associations: sports stadiums, concert halls, and art museums come to mind. Others may remind us of the tent in the wilderness, a space that could be packed up and moved along with a community on a pilgrimage. Last — but certainly not least — is the essential symbol of the domestic structure, the house, which shelters and comforts a family. Symbolic of our mother, this sort of architectural space emphasizes warmth, intimacy, simplicity, comfort, and safety.

The sacred building or space is an image of the creation itself, but creation as it may be reconstructed by different traditions and values — a world of its own, in any one of at least four different versions. Whatever form it takes, as an enclosure it represents order and safety over against chaos and danger. As a symbol of a community's identity and its ultimate values, it both exists in this world and points toward the next. We could say that it has both a horizontal and a vertical axis, functioning like Jacob's ladder, to join us in a finite time, in a limited space, to a particular community, and also joining us to a presence that is infinite, unconfined, and able to embrace all of creation, including its past, present, and future inhabitants — a presence that is palpably living, divine as well as human.

Probably the best illustration of this important intersection between the structure and the community that builds and dwells within it is the rhyme that many children have "enacted" with their hands: "Here is the church, here is the steeple, open the doors and see all the people." For the structure cannot be empty. It has meaning and life only because of the people who, like the child's interlocked fingers, are the living (and wiggling) inhabitants who hold the whole thing together. A church, after all, is its membership, the commu-

nity — not its symbolic container. Without anyone to use or to understand it, the meaning disappears. This presence is what makes a space sacred, whatever its shape, scale, or design. Entering such a space is the beginning of a *human* pilgrimage through symbolic space toward a desired destination. As a place where we engage in sacred activity, it serves as the set or stage for the dramatic enactment of our sacred stories. Finally, it is the focus for our return, the pillow beneath our heads and the ladder between our known earth and our imagined heaven. We are invited to stay, and we are invited to climb.

# The Beautiful and the Disturbing: Art, Taste, and Religious Value

A new phenomenon has appeared in the world of art: warning labels on exhibitions. A few years ago, for example, the Jewish Museum in Manhattan had an extremely controversial show titled "Mirroring Evil: Nazi Imagery/Recent Art." The exhibit was made up of a collection of artworks incorporating Holocaust themes, some of them (in the opinion of certain reviewers) taking irony to an extreme, so that the suffering of the six million victims was reduced to almost playful triviality. One of the works was a set of boxes made to look like a LEGO-toy concentration camp. Recognizing that offense would be taken (and it was), but unwilling to censor any of the works, the museum posted a caveat at the exhibit entrance and included it in the publicity for the show, saying that the works in the exhibition might disturb some Holocaust survivors.[1]

Less recent but far more publicized was the show titled "Sensation," which came from London's Tate Gallery to the Brooklyn Museum in the autumn of 1999. One object in the exhibit got special attention in the press, becoming notorious as the "Virgin Mary with Elephant Dung" painting (otherwise known as *The Holy Virgin Mary*) by African artist Chris Ofili. During the time of the show's run, the media gave so much attention to discussion of the exhibit in general and this painting in particular that the show became a kind of blockbuster, a result primarily of its deliberate intent to be shocking and even offensive (hence its name).

In singling out Ofili's "Madonna," the media came close to ignoring the other objects in the exhibit, including pieces that were much more dis-

---

1. Cathy Young, editorial, *Boston Globe*, 1 April 2002.

turbing to some who attended the exhibit than Ofili's painting: manne-
quins of children with explicit and multiple genitals, a disturbing image of
a child murderer done in a pointillist style by using tiny hands, and maca-
bre works by an artist who specializes in dead animals and animal parts —
all of which had drawn criticism from activists concerned about the abuse
of children and animals. In addition, by focusing on the elephant dung in
Ofili's painting, the press practically overlooked what may have been the
most offensive thing about that particular piece: the small pornographic
images of female body parts, clipped from X-rated magazine ads, that
floated in the background and surrounded the Virgin. Like the show at the
Jewish Museum, this one too had been given a warning label: "The con-
tents of this exhibition may cause shock, vomiting, confusion, panic, eu-
phoria, and anxiety. If you suffer from high blood pressure, a nervous dis-
order, or palpitations, you should consult your doctor before viewing this
exhibition."

Public protest against certain works of art that are deemed to be offen-
sive, shocking, immoral, or simply bad is not new. Every generation of art-
ists has a controversy to point to, often as a kind of groundbreaking mo-
ment in the history of art. The public's (and critics') outcry — from the late
nineteenth century to the end of the twentieth century — against the im-
pressionists, the cubists, and the abstract expressionists turned out to be
just a preamble to the kind of outrage now routinely expressed against the
latest brand of "shock art." The stormy debate over withdrawing federal
funding (through the National Endowment for the Arts) for works that
were deemed obscene was sparked by a retrospective exhibit of the work of
Robert Mapplethorpe, who had died of AIDS that same year (1989). That
debate, like the one over the "Sensation" exhibit, seemed to revolve around
the question of whether art that might be offensive to some representatives
of the tax-paying public should receive public funding.

The issues raised in these conflicts have been predictable: freedom of
expression, freedom to protest (and withhold tax support), and the dangers
of censorship. Sides get drawn along predictable lines. Spokespersons step
forward as heroes of different factions. Artists, museum directors, journal-
ists, religious leaders, moral crusaders, and the American Civil Liberties
Union all have something they want to pitch. Politicians enter the fray on
one or the other side (after carefully weighing the consequences for voter
support in their districts). Some groups cite the First Amendment (which

stresses freedom of expression) and the liberal tradition of tolerance of differences. Others, seeing the offending art as symptomatic of a more general cultural decline, urge a return to traditional values and decency (as exemplified in the art of an earlier generation). Meanwhile, critics, artists, and museum officials insist that the real problem is the American public's inability to understand and appreciate contemporary art. Most current art critics aren't very interested in questions of morality; in fact, many of them seriously doubt the relevance of a criticism based upon such judgments. The categories of "good" and "bad" are, arguably, purely aesthetic ones.[2] However, much of the public still thinks of art as a mediator and container of values, and here we have a potentially serious conflict.

The matter of public funding raises important questions about the public's right to choose, on a case-by-case basis, what will and will not be funded. Currently no system exists to do this, and it is difficult to envision how one could be instituted without inviting chaos. Why should public choice be limited to art, for example? Why shouldn't a non-sports fan have the right to withhold money that might support local sports teams or their stadiums? Would we be allowed to make individual decisions about the value of foreign language teaching in the public schools? Clearly a Pandora's box would be opened if individual taxpayers were allowed to pick and choose the things they wanted to underwrite, item by item, on their tax returns. Obviously, public funding for the arts, however necessary, is a problematic and even perilous benefit. If it takes the goodwill (or meek acceptance) of the paying public for granted, and if recipients of public funding sneer at the sensibilities or tastes of their tax-paying patrons, they should not be surprised at the inevitable backlash. On the other hand, if we revoke all public funding in order to protect an individual's freedom to patronize only the arts he or she chooses, we essentially privatize all art. This will only drive it further out of the range of the appreciation, education, criticism, and — yes — condemnation of "regular" folk with "ordinary" tastes or more traditional sensibilities.

2. Glenn Lowry, "The Art that Dares," *New York Times*, 13 October 1999. The author expresses special gratitude to Wilson Yates for providing this and many of the following articles.

## The Church as Art Critic

I raise these particular cases not because I want to rehash the issues of freedom and censorship, which have found other forums for discussion, but because I believe the church can learn an important lesson from them. By the middle of the fourth century, the church was a pre-eminent patron of the arts and also exercised its power of censorship quite broadly. Nothing that ecclesial authorities deemed to be immoral, heretical, or offensive would have been tolerated, and since the artists depended on their commissions, they at least *overtly* avoided offending the sensibilities of their patrons. As art moved out of the church and into the secular realm, especially in western Europe in the fifteenth and sixteenth centuries, artists gained a new kind of freedom of expression. And although they still served patrons and usually represented their interests, they might or might not be consciously intent upon staying within the strictures of church teachings or morals.

In this century, especially in the West, artists may or may not be Christian or even religious, and most neither expect nor actively seek appraisals of their work from official church bodies. Despite a few significant intersections (such as the Vatican II statement on the arts and worship), the church and the visual arts have gone their separate ways. With the exception of the Orthodox churches, ecclesial institutions have objected to the content of some contemporary artworks, but they have generally drawn back from serious engagement with the style or aesthetic features of contemporary art. For the most part, we also have little, if any, contemporary consideration of an artist's religious vocation. By the same token, art critics, art connoisseurs, and even ordinary art lovers rarely go to churches in order to see art. The work that is taken most seriously is found in galleries and museums, not in naves, chancels, or narthexes.

This leaves the church without much basis for criticism of the art in a museum or gallery, even if some church leaders deem it to be contrary to faith or offensive to religious feeling. Both the church's significantly diminished role as patron of artists and the growing breach between the two reinforce a feeling that the church has no credibility as judge or critic — and certainly no rights as censor — of art. And this is a serious problem, because the church still has enormous influence on the shaping of the values and tastes of the American public. For this reason, religious leaders need to

make an effort to understand and appreciate contemporary visual art, even the art that may initially appear to be antithetical to their sensibilities, and certainly is different from the works of art that were housed in the church of generations past. Church leaders, theologians, and lay persons alike can and must engage culture critically, having the courage of their own convictions, while at the same time being open to challenges and new ideas, even new theologies.

Likewise, artists who want to reach this public have to take it seriously and share some of its values, perhaps even be cognizant of its historical as well as contemporary teachings. Artists cannot choose to ignore the religious feelings and convictions of a large group of people but still ask them to give financial and moral support. The discussion must be open to all, and the church, in all its varied forms, must be one of the participants — and it must be welcomed as well as present if either side wishes to achieve any level of understanding. We will get nowhere if either party shows contempt to the other.

Sometimes the battle between church and artist is less about content than about context, or even about timing. For example, in June of 2001, the director of the visual arts program at New York's Cathedral of Saint John the Divine objected to an artist's refusal to remove or alter her installation in the cathedral's baptistry in time for the baptism of the grandson of the bishop. Based on the floor plan of a Buddhist temple, the installation, which consisted of blue tape and vinyl letters, prominently featured Buddhist verses and surrounded the baptismal font. The artist refused either to amend her work or to remove it, creating a controversy over the appropriateness of non-Christian symbols in particularly sacred or sensitive areas of church space. Although it seems the conflict largely emerged out of a mutual misunderstanding between the artist and the church over their original agreement about the installation, important issues were raised and aired, albeit in painful circumstances.[3] This case was particularly difficult because of the cathedral's general welcome of artworks from different faith traditions and even some that have been enormously controversial, such as the works of Andres Serrano (particularly famous for his photograph *Piss Christ*), which were exhibited in the cathedral that same year.

A somewhat related situation arose a couple of years ago in my home-

3. *New York Times*, 23 June 2001.

town of Newton, Massachusetts. For more than ten years, a local church had provided gallery space (a former chapel) at a well-below-market rent to a small group of critically well-regarded sculptors. The relationship between the sculptors (who were not church members) and church leaders was strained because some members of the church complained that the group's shows periodically featured content that they found offensive ("genital imagery" was mentioned as the biggest problem). But the relationship completely broke down after the minister, who had not been part of the original negotiations, asked the group to sponsor a show of religious art once a year in return for the church's hospitality and consideration in rent. The artists responded that the request for an annual show was an infringement on the artistic control of the gallery and struck them as an outrage against artistic freedom and integrity.[4] The press and a sizable portion of the surrounding community tended to agree with them. Representatives from the church responded that the church had its own integrity and a reasonable desire that art shown within its walls not be incompatible with (or even disrespectful of) its own values and religious beliefs.

One of the obvious issues such cases raise is how a church body fairly and faithfully decides how to welcome art without having to silence its own fears and feelings when the art seems to be contradictory to some of the basic values and traditions of the community itself. Doing this requires a strategy that includes genuine observation and openness to dialogue and education. By "observation" I mean that the religious community involved must actually be willing to look at the work with initial goodwill. (Many of the loudest critics of the "Sensation" show never actually went to see it.) The community must also be open to listening, both to the people who love the work and to those who fear it. This will involve mediation as well as education, so that those who hold different opinions aren't as threatened by or as threatening to one another. By virtue of the looking, listening, and talking, people may arrive at a new place and some common ground.

4. Christine Temin, "Wonderful Ride at Second Church Ends in Dispute for Boston Sculptors," *Boston Globe*, 8 May 2002.

## A Matter of Taste

Now, some may ask how much common ground there can be when it comes to art. The judging of art can sometimes seem enormously subjective. What standards will we use to decide what is good and what is bad? We often hear a kind of snarling comment such as "I don't know much about art, but I know what I like" as a defense against something that critics or connoisseurs declare "good" but that the viewer neither understands nor admires. The idea of aesthetic standards seems almost like a violation of our individual equality (enshrined in the Constitution), which demands that everyone's taste should be equally valued. In America, some might argue, one person's idea of beauty is as good as the next — a matter of personal judgment.

This kind of relativism drives some churches to compromise in commissioning works of art. They seek consensus rather than trusting the artist or hiring a consulting connoisseur. What they end up with may be inoffensive to most members, but it may also be mediocre in quality and bland in content. We can understand why artists are hesitant about such commissions. They are asked to please a committee while still producing something original and remaining true to their own vision and craft. The alternative is for the congregation to live with controversy, even rage, or perhaps to invest in a variety of images and rotate them from time to time. Few things upset the equilibrium of a church community like a change in the physical appearance of the worship space. So, even though the days of iconoclasm are over, many churches are bare of art. The potential for divisive arguments and hurt feelings is just too overwhelming.

Clergy who have weathered the storms of controversy over liturgical changes or new hymnbooks realize that much of the struggle in these cases revolves around the thorny problem of "taste" or style more than theology or even ethics. Even people who are tolerant of a variety of artistic styles in other venues can be easily upset by changes in their worship space, particularly if the changes are a surprise. Common sense dictates that most churches should avoid hanging a painting in the narthex that features a nude, unless the work is over a hundred years old, was donated by a well-respected family, and has long ceased to scandalize. The music of an amplified praise band may offend those who barely listen to its lyrics or message but find its style jarring. Even the temporary installation of an abstract ex-

pressionist painting in a chancel has been known to incite rebellion. Unfortunately, the problem of taste is complex, bound up with distinctions of social class, cross-generational misunderstandings, and changing ethnic and racial demographics.

Judgments of taste can become an unconscious means by which elite groups maintain hidden power by making subtle and snobbish distinctions between different aesthetic choices. In addition, value is too often measured by the purchase price of the object rather than by its intrinsic qualities — the object's "investment potential" rather than its beauty or power. When that happens, the marketplace has corrupted the appreciation of art for its own sake. Sometimes the larger community may be willing to delegate aesthetic decisions to a committee, so long as the style of art they choose is more or less like that of what they already have and changes are subtle and introduced slowly. Friction usually starts when an individual or small group proposes a significant alteration in an aspect of the worship environment or activity. Such friction can be greatly exacerbated if the changes are presented to the community as improvements that will be obvious to the discerning and sophisticated, or that will be embraced by the open-minded and tolerant (casting those who don't like them as either ignorant or narrow-minded). Often the changes are defended on the grounds that they will attract a new or different population. This prospect might itself be somewhat threatening to members of the current community, who are being asked to accept something they neither appreciate nor understand to meet the needs and wishes of people they haven't yet met.

Let me offer another example of a conflict that had elements of clashing "taste" and "perceived value." Several years ago I attended a conference in Dresden, Germany, where academic theologians, historians, and some artists engaged in exploring the intersections of theology and art. We were about fifty strong and, I suppose, could be regarded as a panel of "experts" on art in the church. I remember a visit by an East German parish priest from a small village that was near the birthplace of the famous twentieth-century painter Georg Baselitz. This artist had offered an altarpiece as a gift to this village church, one to replace an ancient linden-wood carving that had been there since the late Middle Ages. That was the string attached: the congregation was being asked to replace their old altarpiece with the Baselitz. The reaction was predictable, I think. The congregation refused the painting, and the priest was distraught to be losing the gift of an extremely valuable object

of art. As a last-ditch effort to enlist support, he asked us to provide a statement that he might use to get some leverage with his resistant congregation.

The congregation's resistance to the new altarpiece didn't necessarily indicate a lack of appreciation for the work of Baselitz; it did indicate (again) the problem of context and respect for a congregation's theological sensibility. This became clear when we saw a reproduction of the painting itself. Losing a treasured (but not necessarily valuable) altarpiece may be a matter of sentiment and disruption of tradition. But accepting a Baselitz in its place might require more than training and tolerance, largely because Baselitz paints figures upside down (see, for example, fig. 6.1 on p. 134). This particular image of a crucified Jesus that was made for the altar of this church showed him upside down — that is, with his head down and his feet at the top of the canvas. The artist had good reasons for doing this, of course, and the painting might or might not be an excellent representative of a new form of figurative painting. But an altarpiece for a particular church becomes more than one artist's expression, since it exists for a whole community and should speak to them as well as expand their vision. This image baffled the congregants — even seemed to mock one of their central faith symbols. So the "consultants" voted with the congregation.

We need to beware of the real and dangerous possibility that we can succumb to elitism if we too quickly buy in to the judgment of the art market or critics and dismiss the values or sensibilities of regular folk and the art that they like. We can make too strict a distinction between "high" or "fine" and "low" or "common." The traditional can work very successfully, especially if it weaves together elements of the familiar and the ancient, with some flexibility to accommodate the contemporary. The old may be beautiful, and it has the advantage of having been tested and honed over time to deliver its message effectively. At the same time, good art, like good liturgy, should offer both continuity and challenge. That something may be "old" may not be a good enough reason in itself to keep the object as the focal point of a worship space.

Not all "old things" are worth preserving. Art that has ceased to challenge — that has become stale and lost its dynamic power — may have reached its limit of value. Old symbols, recycled without any effort to relate them to contemporary realities, may need to be moved to the storage room. Art that projects only one emotion is manipulative and shallow. Some church art has been around so long that no one notices it or could tell

**6.1. *Tanz ums Kreuz,* by Georg Baselitz**    Copyright © 1983 Georg Baselitz

you what it portrays. Some art is simply boring. The emotions that this art evokes are uncomplicated; we know immediately how we are supposed to "feel." Often such art reinforces values of an earlier generation rather than reflecting, challenging, or clarifying the values of this one, usually by senti-mentalizing images from past times and honoring members of families that were once pillars of the community. Some art is cloyingly tender or sweet, and people may draw some consolation from it — perhaps even some inspiration. If it serves this positive purpose, some might ask, how can we dub it "bad art"? I would answer: If the work presents an idealized, innocuous world, without any attempt to challenge the viewer at any level, how can we call it "good art"?

Frank Burch Brown has written one of the best recent studies of this difficult matter of telling "good art" from "bad art"; the title is *Good Taste, Bad Taste, and Christian Taste*. A few summary sentences from his first chapter address the problem quite directly:

> But what of religious art that many would regard as in some sense lesser in quality? Questions of aesthetic value obviously cannot be ignored from a theological perspective; but neither can they be answered apart from considerations of context. And even when the art in question seems aesthetically deficient, this hardly means that aesthetic factors are simply irrelevant to its religious functions. It is surely worth contemplating that the very art that some trained critics and art lovers regard (with some reason) as sentimental kitsch is rarely regarded as cheap or inferior by the people for whom it serves devotional purposes.[5]

While acknowledging that matters of taste can produce factions as well as fractures within communities, Burch Brown maintains that we may be able to chart a course that can heal the wounds and assuage the anger or outrage at what may feel like disrespect. Such a course would require that groups with divergent tastes or sensibilities try to understand some of the qualities in the "other" that appeal and that may hold meaning and value, however opaque to the non-appreciative audience. Despite the title of his book, Burch Brown does not suggest that the measure of "good taste" or "bad

5. Frank Burch Brown, *Good Taste, Bad Taste, and Christian Taste: Aesthetics in Religious Life* (New York: Oxford University Press, 2000), p. 11.

THE SUBSTANCE OF THINGS SEEN

taste" is simple. Judgment of art in a religious community is more than a matter of formal categories. It must also involve a consideration of the variety of functions that art serves in a particular group, as well as the ways in which it might hurt.

## The Artistic Offensive

The point about hurtfulness brings us back to the "Sensation" and the "Mirroring Evil" exhibits. The protests against them were not about aesthetic values or artistic styles, although certain innovations in style have also drawn storms of protest over the centuries. What was at stake was much more than a matter of taste or even the need to respect or tolerate different religious sensibilities. I'm not sure the arguments were even so much about the content of the art as the attitudes of the galleries, curators, and even the artists who *appeared* to be deliberately disrespectful. They were about deeply held religious beliefs, and they raise an important question: What, if anything, should we do when we think our religious faith is truly — directly and consciously — under attack, by artists or anyone else? This was the claim of some of those who picketed outside the "Sensation" exhibit at the Brooklyn Museum — alongside members of the animal rights organizations. What both groups were saying is that images can hurt: they can do harm.

At the time that the newspapers were reporting the story about the "elephant-dung Madonna," the curator and some interviewers stepped forward to provide the "straight story." Artist Ofili's choice of medium was not meant to be offensive at all, they explained, since in many African cultures elephant dung is venerated. According to Arnold Lehman, curator of the Brooklyn Museum, "What they [those cultures] tell us is not a story of blasphemy, but of reverence."[6] Well, reverence to a point, at least. The argument that Ofili meant no particular insult to the Virgin Mary was supported by reference to one of his other paintings in the show, *Afrodizzia*, in which Ofili also used elephant dung alongside the names of Cassius Clay, Miles Davis, and Diana Ross. This juxtaposition led Frank Rich to dub Ofili an "equal opportunity dung artist."[7] In an interview, Ofili — himself a Ro-

6. Reported by J. Kifner, *New York Times*, 1 October 1999.
7. Frank Rich, *New York Times* (Op. Ed.), 9 October 1999.

man Catholic — took a different tack, explaining that dung is often used in African art as a symbol of fertility. Perhaps the (arguably) pornographic use of women's body parts was meant to suggest fertility as well, since Ofili also claimed that he saw his work as "a contemporary version of the classic depiction of the Madonna surrounded by naked *putti*." Others simply saw the painting and its controversy as a publicity stunt to drive up its price for the benefit of the work's owner, who had already planned to put all the pieces in the exhibit up for auction.[8]

In a strategic move, Ofili's defenders, among them James Welu, then president of the Association of Art Museum Directors, compared the fracas with the Catholic Church's attacks on earlier religious works now considered religious treasures, including those by such artists as Veronese, Botticelli, Tintoretto, and Caravaggio. The old masters, admittedly, had some pretty racy Madonnas, and it is true that Caravaggio was assailed for using a prostitute as a model for his painting titled *The Deposition of the Virgin*. (Caravaggio employed models of questionable virtue, actually.) Welu, commenting on the use of dubious characters in old masters' paintings of religious subjects, was quoted in the same article as asserting, "The realism, the dirty feet on the saints — people said this was a sacrilege. We look and say it makes the saint more real for us."[9]

Of course, Welu didn't explain how including images of women's genitalia in a painting of the Virgin Mary makes her more *real* for us. Nevertheless, Welu's argument has some validity. What critics find ugly or the devout find offensive often becomes a kind of icon — of the art establishment, the church, or the popular culture — many decades after it was rejected or banned. Condemnation seems almost a rite of passage for a great artist — a mark of genius and true creativity. Van Gogh was derided; Blake was disliked; Roualt was rejected. Now their images are everywhere, in bookstalls and gift shops, appearing on posters, T-shirts, and Christmas cards. These artists have achieved widespread recognition and acceptance at last, but at the price of potential banality.

While some artists have been derided for their style — Rouault, for example — the Caravaggio parallel points out that others have been condemned for the content of their works (or their medium). In his own time,

---

8. Robin Cembalest, "Battle in Brooklyn," *Art News*, November 1999, pp. 61-62.
9. Cembalest, "Battle in Brooklyn," p. 62.

Caravaggio's paintings were called "shocking" and "offensive," just as Ofili's "Madonna" has been. The matter of content is particularly relevant here because the subject matter is religious, in both cases Christian. And in both cases, viewers objected to what they believed was an irreverent — even mocking — use of a figure or an image sacred to them. Many of the objectors to the Ofili Madonna claimed that it was "anti-Catholic" in particular, since the Madonna has a special place in Catholic art and piety.

Ofili, who was born in Britain of Nigerian parents, has denied that he had any intent to mock or deride this holy figure. So now we have a clash between artistic intent and viewer perception, just to make the whole matter more complicated. Still, although the message received may not have been the same as the message sent, the resulting reaction remains: that something sacred has been damaged. We dare not minimize the strong, almost primal emotions that emerge when sacred symbols are believed to be under attack. A cool or detached stance is simply not possible for people who are deeply attached to such symbols. I would further argue that those artists who choose (or dare) to incorporate such images in their paintings do so with full awareness of these possible reactions, and that this also can be a good reason for including them.

### The Beautiful and the Disturbing

Artists who believe their role is to reflect upon reality, upon the whole of human existence, and to present the truth as they find it rather than to "make something of beauty to the eye alone" often turn away from the conventionally "beautiful" and instead present images that shock or disturb us. Including traditional religious symbols in their work often serves as a vehicle for such artists, a way of opening up viewers to consideration of deeply religious and profoundly existential matters. This is the farthest thing from mockery. Such a task is very serious and can be deeply faithful even if some viewers or audience members feel scandalized.

A friend of mine, a Protestant minister in Sydney, Australia, converted the sanctuary of his centrally located church to serve as a gallery as well as a worship space. His church had an important outreach program to the city's homeless and funded many of its programs by running a popular weekly outdoor art market. A few years ago the visual artist Dennis Del Favero in-

stalled a multimedia exhibition, "Yugoslavian War Trilogy," in a small, chapel-like space specially created for it. Projected on the walls of this room were some photographs and text of a news story about a grieving Bosnian mother who was taking the head of her dead son to be buried after she had seen enemy soldiers using it for a soccer ball. The images could be described as a modern pietà, evoking the grief of a mother for her dead son and leading us to pray that we might find some meaning or message in this tragedy. Like a crucifix, such frightening and outrageous images of human suffering might awaken our pity and, more important, move us to action.

Nevertheless, most modern churchgoers, far more than museumgoers, object to being confronted with terrifying and contemporary images of human evil and suffering. They may be used to seeing Christ upon the cross — a traditional image that hardly ruffles sensibilities — but feel assaulted by a modern rendering. Even where the crucifix is acceptably familiar, it is often moved to the side, replaced with the empty cross as a sign of triumphant resolution, joy, and reassurance. We could argue that the church is a place for solace and support, and that is true. However, it is also a place for truth to be told and reality to be faced, for hypocrisy to be exposed and warnings to be issued. We must confess our sin before we can be absolved. And to confess sin, we must be made aware of it. We should not be allowed to settle back complacently and comfortably when there are wounds to be dressed, the hungry to be fed, and the homeless to be sheltered. Someone needs to shake us up and wake us up, and it's very often the artists who do that.

Several well-known examples come to mind that illustrate the courage of an artist to address human sin and suffering. Goya was driven to show the horrors of war at the beginning of the nineteenth century in his painting of an execution squad, *The Third of May*, just as Picasso did almost a century and a half later with his *Guernica*. Art's potential to offer social criticism and even to serve as a vehicle for activism has never been eclipsed, even at times when the leading galleries and museums, as well as the critics, seemed to be more focused on art that attended more to formal concerns of color, line, texture, or balance. Perhaps one might argue that the most noble of all works would be those that combined aesthetic beauty with the whole range of human experience, that could both confront and transport.

To my mind, one of the greatest examples of this full range in a single work of visual art is Matthias Grünewald's Isenheim altarpiece. The paint-

ing was created in the late fifteenth century for the chapel of a hospital in Isenheim, Germany — a hospital that treated those suffering from Saint Anthony's fire (ergotism), a disease that they had contracted from eating spoiled wheat and that ended in a gruesome and inevitable death preceded by a horrible suffering from festered sores all over the body. The altarpiece now hangs in a museum in Colmar, France, where it is visited by hordes of pilgrims to art. Even in this religiously neutral setting, however, the painting deeply affects its viewers.

This complex piece of work has three different layers that open to show three different sets of images, making it a kind of triple triptych. The first two layers speak to the particular point I want to make here. When the altarpiece is entirely closed, the center panel shows the crucifixion in a dark, retreating landscape. This is a vivid presentation of suffering and grief. Christ's body hangs from the cross, physically distorted and twisted. His head sags on his chest, the crown of thorns piercing his forehead and causing blood to run over his face, which is caught in a moment of utter agony. The fingers of his hands are splayed as if in a last entreaty for release from pain. Sores cover his nearly nude body, sores probably similar to the ones borne by the patients of the hospital. To his left we see John the Baptist and the lamb of God; to his right we see his mother, Mary Magdalene, and the Beloved Disciple. The Magdalene, her hair down in flowing disarray, is the image of distraught grief, while his mother, caught in a swoon by the Beloved Disciple, is a figure of despair and loss. The interaction of dark and light colors — red, white, green, and gold — make this composition starkly mystical as well as terribly disturbing (fig. 6.2 on p. 141).

On either side of the crucifixion are portraits of the saints. To the left we see Saint Anthony, for whom the disease was named (possibly because he suffered from the visits of demons just as the victims did during the last stages of their illness), and the patron saint of the order who ran the hospital. On the right we see Saint Sebastian, whose many arrow wounds make his body look as if he suffered from the disease himself. Below, in the predella, we see a lamentation over the dead body of Christ, with his mother, Mary Magdalene, and John tenderly laying Jesus' corpse into his tomb, a stark reminder of the ending of all human bodies.

J.-K. Huysmans describes this image as the work of "a barbarian of genius" who understood and captured the particular piety of the poor and the suffering sick. Addressing the gruesomeness of the image, he says,

**6.2.** **First view of the Isenheim altarpiece in the Musée d'Unterlinden,**
**Colmar, France**   Musée d'Unterlinden/Bridgeman Art Library

That awful Christ who hung dying over the altar of the Isenheim hospital
would seem to have been made in the image of the ergotics who prayed
to him; they surely found consolation in the thought that this God they
invoked had suffered the same torments as themselves, and had become
flesh in a form as repulsive as their own; they must have felt less for-
saken, less contemptible. It is easy to see why Grünewald's name, unlike
the names of Holbein, Cranach, and Dürer, is not to be found in the ac-
count books of the records of commissions left by emperors and
princes. His pestiferous Christ would have offended the taste of the
courts; he could only be understood by the sick, the unhappy, and the
monks, by the suffering members of Christ.[10]

10. J.-K. Huysmans, *Grünewald: The Paintings,* trans. R. Baldick (New York: Phaidon,
1958), p. 25.

But the awful crucifixion scene divides down the middle to open wide to the second triptych, which is as glorious and triumphant as the first is dark and fearful. The colors are suddenly bright, saturated, and almost luminous. The scenes are, from left to right, the annunciation, the nativity with a chorus of singing and dancing angels, and the resurrection of Christ. The annunciation and the mystical angelic concert are concealed behind the image of the grieving Madonna and Magdalene, while the nativity and the resurrection lie behind the image of the crucifixion and John the Baptist with the *agnus dei*. Grünewald has presented Christ's resurrected body as startlingly transformed and suffused with light. He floats up out of his rocky tomb, his raised hands and head framed by a huge golden nimbus. The three images are distillations of pure joy, just as the crucifixion is the epitome of agony and grief (fig. 6.3 on p. 143).

Although we don't know exactly how this altarpiece was used, when it was open and when it was closed, we can assume that it was a visual focus of the prayer for healing, or at least for an end to suffering, that was carried on by the monks and patients in this hospital. The afflicted would see that the Divine One suffered as they did and find solace in that sense of participation, theirs with him and his with them. But even as they found comfort in that promise of compassion, the interior of the image promised something even more wonderful: not just release from illness and pain but a true and even triumphant wholeness in the resurrection to come.

Similar agonies are known to our generation, and artists have offered profound theological statements in the iconic language of our own era. The photograph *Piss Christ* by Andres Serrano, which drew a firestorm of criticism for being sacrilegious, offensive, and anti-Christian, may have something in common with the Isenheim altarpiece. Serrano himself spoke of the work as a juxtaposition of the sacred with the profane, but others took it as a reference to the modern preoccupation — in the time of AIDS — with body fluids as charged with both life and death. The photograph, which shows a plastic crucifix plunged into the artist's blood and urine, speaks deeply to me about Christ's bodily incarnation and the sanctification of human life, especially the life of those who suffer. Like Grünewald's gruesome Christ that is transformed into a radiant, transcendent one, Serrano's crucifix is submerged in what it means to be human, and in that submergence finds a glowing, golden beauty.

This art, like life, juxtaposes beauty and horror, vitality and death. This

**6.3. Second view of the Isenheim altarpiece in the Musée d'Unterlinden, Colmar, France**

Musée d'Unterlinden/Bridgeman Art Library

is the essence of its truth. In the Middle Ages the gargoyles on the outside of a cathedral, the bloody images of the martyrs, and the scene of the Last Judgment over the cathedral's entrance doors all alarmed, admonished, and fascinated their viewers. But the church itself was like the interior of Grünewald's altarpiece. Once inside, the visitor found the image of paradise, with saints and angels offering consolation, hope, and delight to the faithful. Such juxtaposition is telling. Without the ugly, we cannot know the beautiful. Without desolation, we cannot know hope.

Another fifteenth-century painter, Hieronymus Bosch, painted the hellish nightmares that I remember staring at with enthrallment as a small child. The images graphically portrayed the consequences of vice and sin. Sometimes they opened up into beautiful pastoral landscapes with dancing villagers, but terror was never far out of the picture. The happy utopian scenes were marred, yet made true, by the proximity of violence and wickedness. I was similarly spellbound some years ago, in Dresden's Hofkirche, looking upon a modern pietà by the sculptor Friedrich Presse. The monolithic and starkly beautiful monument was a memorial dedicated to the tens of thousands of Dresden residents killed in the Allied bombing that almost completely destroyed the city in 1945. At first glance I thought it was made from blocks of white granite. Then, as I recognized that it was made from strong yet delicate Meissen porcelain, I recognized that this work was a powerful contrast of fragility with strength, tragedy with beauty, sorrow with hope (fig. 6.4 on p. 145).

A new kind of prophetic artist may be the photojournalist whose work places searing images of human destruction, hatred, and loss on the front pages of our daily newspapers. Horrifying as these images are, they act as our alarm, calling us away from complacency, apathy, and cynicism. We may even turn the page to find a countering image of hope and redemption. Artists use such juxtaposed images, the terror and the beauty, in the same way that the biblical texts and the liturgy, which contains them, juxtapose shadow with light, sorrow with triumph, bondage with exodus, suffering with salvation. The shadow of the crucifixion falls over Palm Sunday, just as those palms of victory will later be burned to ash to remind us of our mortality. Artists will and must make art in the midst of tragedy and despite dehumanizing conditions and situations. To make art is to transcend a situation or perhaps even to infuse it with grace and truth and humanity, to tell the story that will dignify its participants. This neither takes advan-

**6.4. Pietà, by Friedrich Presse, Gedächtniskapelle in the Hofkirche, Dresden**

tage of nor offers escape from reality, but rather gives meaning and value to life as it is lived, sometimes in wretched or painful circumstances.

## True and False Art

We do finally need to ask whether there are some kinds of art that are wrong for the church in particular, that will *not* do and should be removed. Of course, Plato tried to delineate what he might call "good" art for his Republic and ended up banning art altogether. Even so, the question of whether art — and what kind of art — can make us better people is a vital one. We need to ask where there are standards that could find certain art immoral, idolatrous, or contrary to the Christian faith, and who might promulgate such standards. Should a church group take a stand against art that it views as misrepresenting its most basic doctrines and essential teachings? What about art that is racist, sexist, violent, hate-mongering, or abusive (even pornographic)?

Despite centuries — maybe even millennia — of debate about the

problem of art in the church — its link with idolatry or even with blasphemy — I don't think we ever will have a very precise answer. We are especially at a loss now, as we increasingly recognize and value the diversity of faith traditions, cultures, and perceptions of others in our world. Moreover, art simply cannot be evaluated as if it made a dogmatic argument or promulgated a rationally conceived statement of faith. Art isn't at all like dogmatics. It isn't even very much like constructive theology. Visual art, like poetry, doesn't restate propositions or even directly parallel them. It projects a vision, one that we must see to understand, and whose truth lies outside of verbal explanation. Good art *is* about truth — a truth that transcends visually coded symbols in a catechism or the literalistic reproduction of a biblical story. This truth is perceived but not expressed in verbal discourse, and it can't be subjected to the same tests of evidence or coherence applied to such statements. And even though the truth found in art lies outside linguistic precision, if we say that art can be true, then we must admit that it has the potential also to be false.

The representation of the Virgin as a young Flemish woman sitting at her reading desk in a comfortable middle-class home is not "true" in a literal sense. Nor is an image of a tender-faced Christ, dressed in sandals and robe, knocking on a door — the "heart's door." Neither is the portrayal of Jesus as a homosexual young man in an east Texas town — a presentation that outraged some Christian groups when it appeared on Broadway in Terrence McNally's play *Corpus Christi* a few years ago. And yet each of these images has a kind of "truth" to share, a truth anchored in metaphorical and existential truths rather than historical claims.

The film *The Last Temptation of Christ,* released in 1988, drew both praise and fire. Some people thought it a mediocre piece of cinema from an artistic perspective, but that criticism seemed almost beside the point at the time.[11] Biblical conservatives argued that the plot showed a version of the life of Jesus that contradicted one drawn directly (and only) from the four Gospels. The film diverged significantly in many respects from the historical narratives found in the New Testament and added some that cannot be found there, including a fantasy sequence in which Jesus dreams that he makes love to Mary Magdalene and then marries Mary of Bethany — Jesus' "last tempta-

11. See Lloyd Baugh, *Imaging the Divine: Jesus and Christ Figures in Film* (Kansas City: Sheed & Ward, 1997).

146

tion." The fact is that neither the original novelist — Nikos Kazantzakis — nor the movie director — Martin Scorsese — had intended to produce a narrative re-enactment. Their aim was rather to explore the possibilities of the human Jesus beset by temptations, doubts, and confusion. In this film, Jesus is a very human character in search of an identity, which he finds only through a very human effort. The film could thus be understood as a kind of midrash on the Temptation narratives of the New Testament — imagining and dramatically constructing other possible encounters just after Jesus' baptism, when he is tempted by Satan. In any case, we should see the film on its own terms, as a piece of art, not a Bible study. The film is more like a sermon than a Sunday school lesson. It starts with a source text but then tries imaginatively and artistically to find contemporary relevance in it.

Since the story emphasizes Jesus' humanity, one might call the Christology reflected by the movie "low." In fact, according to some traditions' teachings, it is so low as to be heretical. The Greek Orthodox Church excommunicated Kazantzakis for heresy, and the Catholic Church added his novel to the list of forbidden literary works. Director Scorsese, an avowed Roman Catholic, saw his film boycotted by the U.S. Catholic Conference, and the theatres in which it opened received bomb threats. Yet neither Kazantzakis nor Scorsese, to credit their own statements, intended to offend or mock Christian teaching or the figure of Christ. Both were simply using their art forms to engage and break open a powerfully religious theme. From some perspectives, this film transcended all the usual clichés of Hollywood "Jesus" movies, which are predictable in their packaged piety and standard dialogue. But portraying Jesus as neurotic and tragic, confused and dependent on Judas (of all people), struck many as blasphemous. This returns us to the problem of sacred symbols. Are there certain figures or motifs whose use must be guided by certain standards and limits? If artists push those boundaries, are they being disrespectful? Can they even hurt the faith itself — is such a thing even possible?

Other examples of art that have been picketed, banned, or hidden away by clergy and curators include the feminine crucifixes — Christa, Christine, and her sisters — that appeared in the 1980s (fig. 6.5 on p. 148), which were attacked by conservatives and liberals alike. Conservatives, of course, argued that Christ was male and that to show him as anything else was to make a mockery of his actual incarnation. Feminists countered that the human nature which Christ assumed was a generic human nature and that its

**6.5. *Christa*. Bronze sculpture, 5′ × 4′, by Edwina Sandys**
Copyright © 1974 Edwina Sandys

assumption included women as well as men in salvation. Still, the image of the naked, crucified woman upset those who found it violent and even sexualized. They feared a different message was being sent than one of equality before God — a message that might lead to the abuse of women. Other viewers agreed that the image was violent, but they believed the figure was a powerful condemnation of such abuse. Did the image constitute heresy? Was it, in some way, similar to pornography? The controversy was itself a profound learning experience for everyone who engaged the problems and the potential of such a startling image.

On the other hand, some more traditional images are now acceptable. Looking back at the art of the Middle Ages, I think now we would agree that the symbolic portrayals of Ecclesia (Church) and Synagoga are "untruthful," immoral, and even heretical. Ecclesia is personified as a triumphant queen, while Synagoga is presented as a broken, blinded, and forsaken figure of pity and defeat (fig. 6.6 on p. 150). To take another example, while we might find them amusing now, the presentations of God as a white-haired and enthroned king have left such an indelible mark that many children today still think of God in this way. Such images can be harmful in their potency. Consider the fact that Mary, the mother of Jesus, rarely grows old in the traditional iconography. This seems not only historically impossible but theologically unnecessary; and it is a lost opportunity for Mary to be a visual source of identification for the older woman, the widow, and the grieving, aged mother, all of which Mary most likely became over time. Finally, the many representations of Mary Magdalene as a reformed prostitute are based on a pastiche of different women from Scripture. The Magdalene is never described as a prostitute or even a sinful woman in the Bible; rather, she is the one who comes to the tomb on Easter morning and meets the risen Christ.

If the definition of truth in regard to Christian iconography technically depends on the conformity of a proposition with the Bible and the councils of the church, we certainly could argue that these works are fundamentally false. However, even this puts us on the shaky ground of interpretation, where everyone is able to see something in a slightly different light or find a text that offers a contradictory reading. Is the Jesus of Kazantzakis a false or heretical portrayal because he is not divine enough? Or because the fantasy sequence is nonbiblical? Are we willing to apply such criteria to other traditional art forms — Christmas carols, for instance? The doctrinal accuracy of the Christa figure is problematic based on the confession that Jesus was a

6.6. Synagoga *(left)* and Ecclesia *(right)* from the west portal,
Notre Dame Cathedral, Paris

historical human male. But this image is emphatically *not* trying to be historically accurate but rather attempting to symbolically represent a particular theological argument about Jesus' shared humanity. Jesus was not an actual lamb, either, although the art of the church has long showed him in just this way, with only occasional objections (fig. 6.7 on p. 151).[12] It is important to remember that the four Gospels all present different perspectives or images of Christ, and as such convey the message that no single picture is complete in itself.

As Christians, we acknowledge the absolute necessity of letting the ancient Gospels speak to our current situation. This is fraught with risk, but it also is the work of the artist to be interpretive, relevant, and inspirational. There are no clear and generally agreed-upon rules for doing this. Nor are

12. For example, see the decrees of the Council of Trullo (or Quinisext Council), can. 82, in vol. 14 of *The Nicene and Post-Nicene Fathers,* second series, ed. Philip Schaff and Henry Wace (Grand Rapids: Eerdmans, 1979), p. 401.

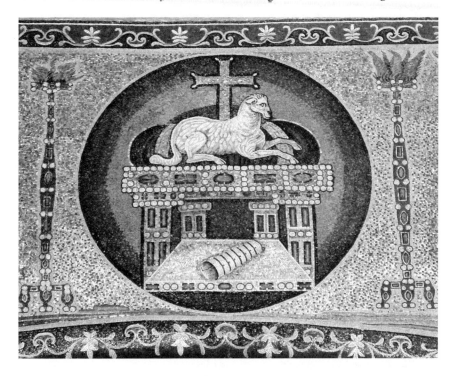

**6.7. Jesus as lamb, from the Basilica of Saints Cosmas and Damian, Rome**

there any ultimate standards for judgment that all of us could adopt. But then, the Gospels themselves are not history. They offer four different perspectives, each with a slightly different image of Jesus. Throughout its history, the church has used these different presentations to make sense of the story in its own time and place, updating and reflecting, exploring and challenging along the way. This is the work of the interpreter: to engage the Word through the arts, whether preacher, teacher, artist, or poet. And this work is essential to shape and sustain a living community of faith.

When we study the Scriptures themselves as pieces of art, we will note that they are filled with shocking and disturbing things. The parables, now so often reduced to didactic fables, must have been somewhat baffling and even upsetting to their first hearers. The Messiah is presented as someone who seems to scoff at traditions and religious laws, dines with sinners and outcasts, and inverts the expectations of a kingdom of God. In the end, grieved and deserted, that Messiah's agony and ignominious death are both

scandalous and glorious. Like Grünewald's altarpiece, the crucifixion opens up down the middle to reveal its hidden truth. That truth may be different for every reader or viewer of art. The artworks that I see may come to have meanings for me unintended by the artist, and those meanings may change as I change, grow, and have new encounters with the image. All these different interpretations are true, and art that is true accommodates and even invites this.

How do we portray Christ in a meaningful way today in order to avoid using the cliché or repeating the banal? I can't think of any other way than to reach into the meaning of the Christ story — to find the multiplicity of images that are available to us. We may bypass the "beautiful Jesus" of another generation, and the "royal Jesus" of the Middle Ages, enthroned and splendid, in our search for an image that conveys the truth as we see it. That might include a Hispanic Jesus, an Asian Jesus, a Jesus dying of AIDS, a single-mother Jesus, or even a Jesus surrounded by elephant dung. And we will have to understand that our vision might shock and anger those who don't see it in the same way we do. Perhaps the only measure of judgment is whether the representation inspires us in some way to greater love and compassion for the world in which we live.

Before we criticize their works, whether on the basis of content, style, or intent, we need to think about what our world would be like without artists. Their creativity and audacity broaden our vision to encompass things that we could not imagine on our own. When they shock us, we are forced to think harder about what we really believe. Have we been hanging on to old images that are no longer relevant? If we banned the Ofilis (even from our own minds), we might also be banning the Michelangelos. At the same time, artists also need the theologians, the faithful, *and* the debates. Not to engage them would be to fail to take their images seriously. Ultimately, no one, artist or theologian, is above reproach, challenge, and disagreement, even a fight now and then.

Finally, we must look and look again. The church cannot *ignore* the arts, whether they are inside or outside of it. And the arts that the church welcomes must not be merely "nice" and "safe," unless we want to condemn ourselves to the starvation of the Christian imagination and the dissolution of the Christian conscience. There is no sin in changing minds, breaking with traditions, or challenging standards. The church has met this challenge before and certainly can meet it again.